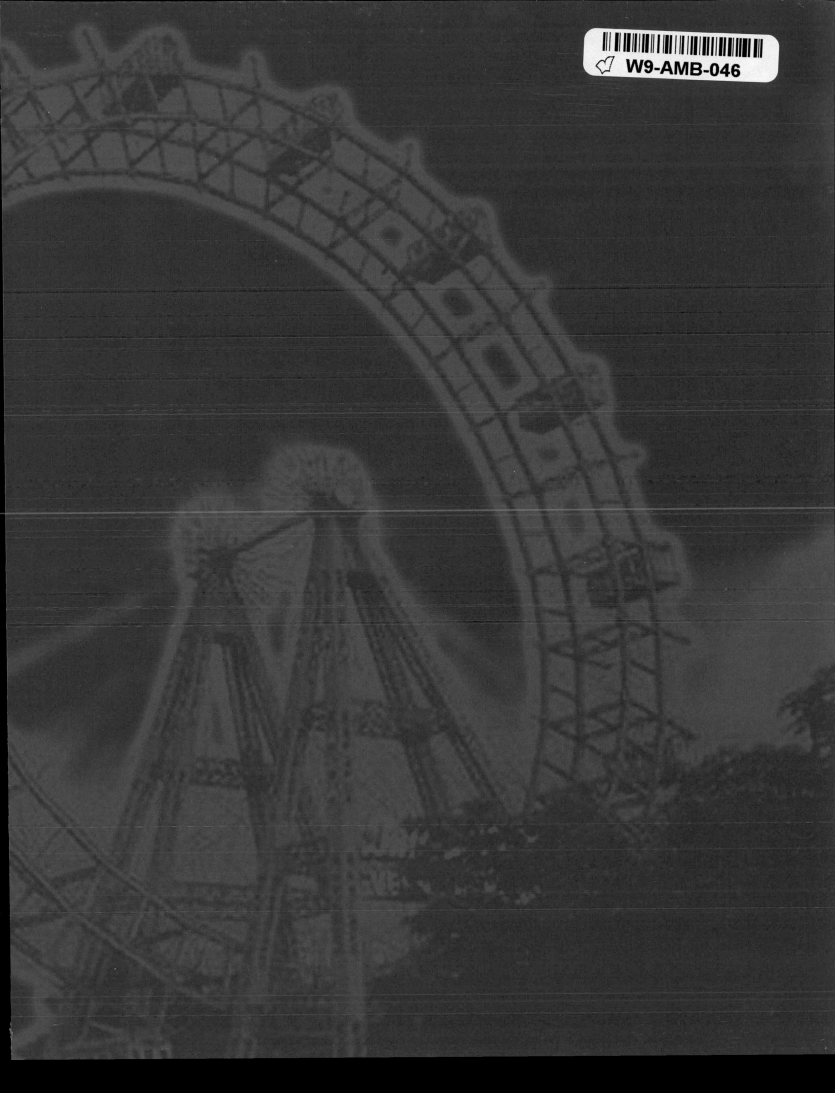

Journey through

AUSTRIA

Photos by

Martin Siepmann

Text by

Walter Herdrich

Stürtz

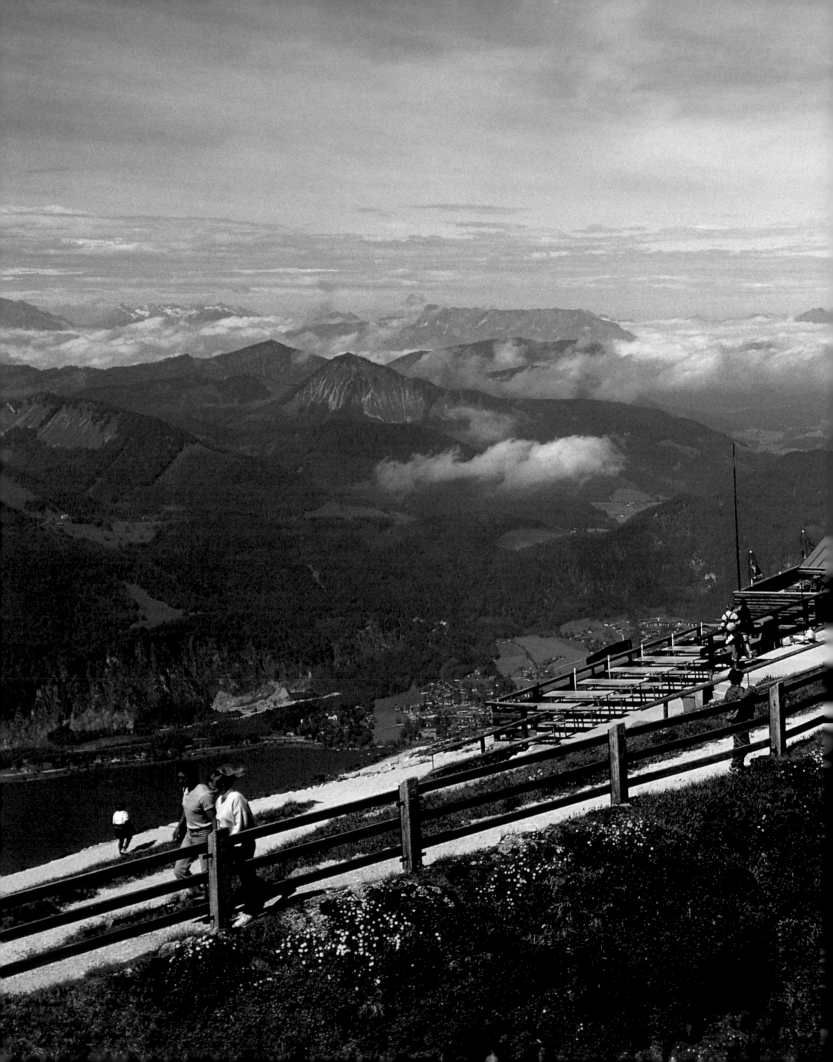

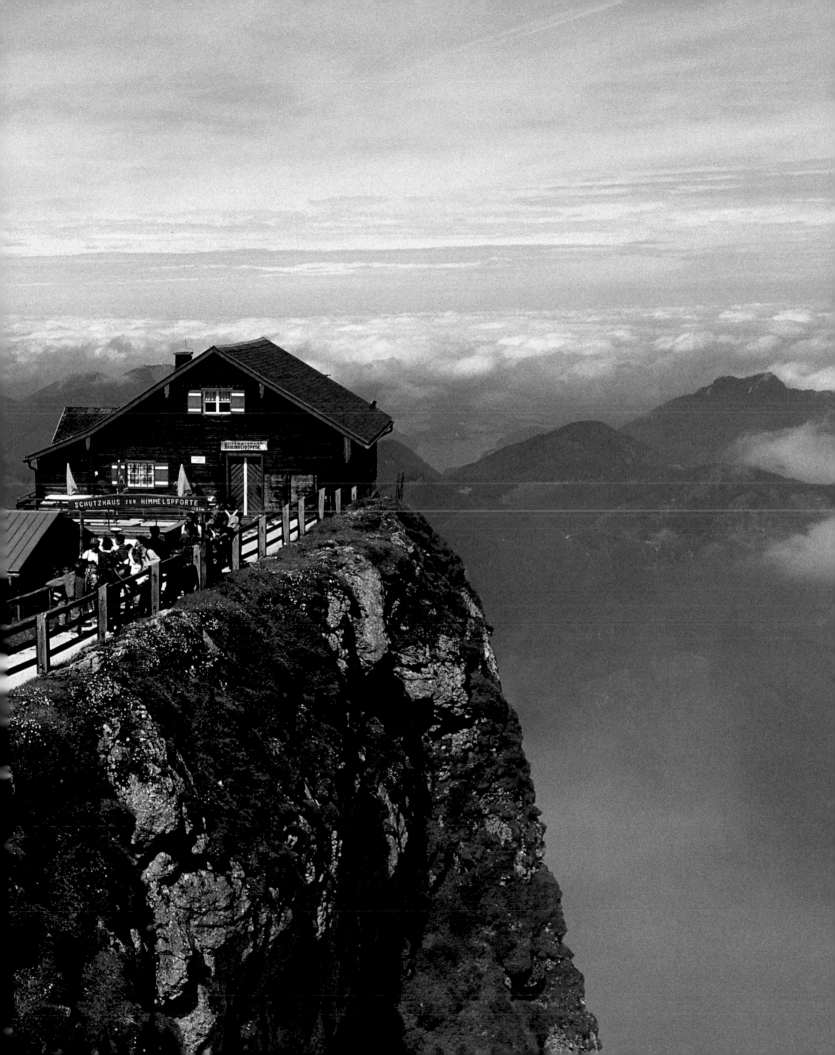

CONTENTS

First Page:
A tiled reminder of the Dual Monarchy on St Stephen's cathedral.
Page 6/7:
View of the Salzburger Land from the Schafbergspitze.

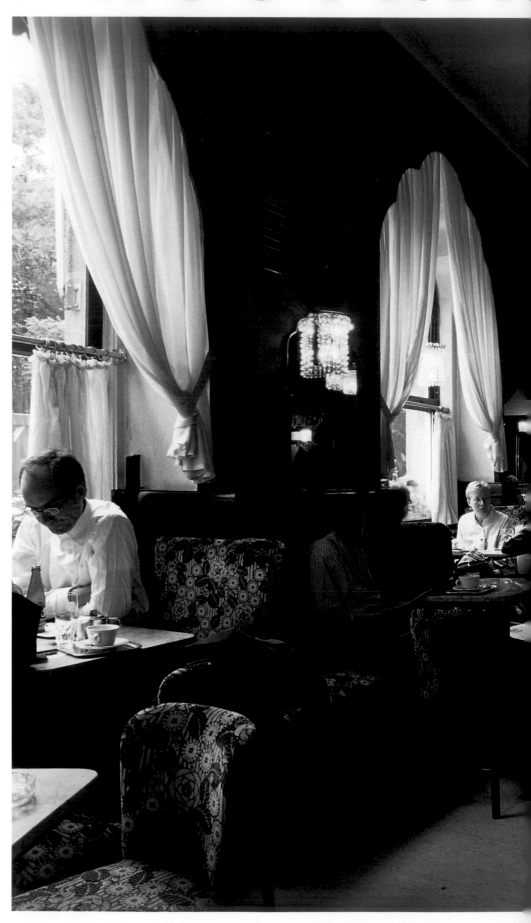

At the Viennese coffee house you can get away from your house or flat for a while and yet still feel at home. Each establishment has its own unmistakable style, such as that of the Café Tiroler Hof shown here. Coffee house connoisseurs are, in the words of Alfred Polgar, »people who want to be alone but need company to do so«.

Vienna and the wine tavern, Haydn and Mozart, the Salzburg Festspiele, snowy slopes and green Alpine pastures beneath jagged peaks are standard repertoire in tourist brochures for Austria. Small wonder, then, that the image the small Alpine republic enjoys abroad is not seldom riddled with clichés. If you ask visitors – and especially Germans – for their lasting impressions of Austria, they will reminisce about fantastic skiing on well-maintained pistes, bathing holidays and boat trips on the lakes of Carinthia and the Salzkammergut and mountain hikes among the majestic summits of the central Alps.

True to the glossy brochure this is all to be found here, as are the operas in Bregenz, the Golden Roof in Innsbruck, the famous coffee houses in Vienna and the Big Wheel at the Prater funfair. These are, however, mere splashes of colour in the broad palette of Austrian culture, highlights of the unique way of life the people here are privileged to lead.

For Austria has much more to offer than glaciers, ski lifts and chamois mountain goats, health resorts steeped in history and architectural reminders of the glorious reign of the Habsburg monarchy. This is a country which is surprisingly diverse and unexpectedly modern. The eight provinces of the republic,

with their capital of Vienna, are so very different from one another in appearance, mentality and culture; they boast a variety you would not expect to find in such a small area.

THE RISE AND FALL OF THE HABSBURG EMPIRE

Despite its relatively brief career as a republic (the Austrian republic was founded in 1919), the former heartland of the fallen Habsburg empire is still deeply marked by the rise and fall of the Danube monarchy, of whom it was once said that if it hadn't already existed, it would have had to have been invented. Barely a century after the end of the Austro-Hungarian Empire, following the fall of the Iron Curtain and Austria's membership to the European Union, the wind of change has swept across the country, once again placing it at the geographical centre of a new multinational community intent on growing together. In order to understand this new Austria, interested visitors often feel obliged to catch up on a lesson or two in Austrian history, with the Dual Monarchy the historical highlight and 1918 its inglorious end.

How did this Austria evolve? It all began with a German emperor, Otto II, giving Frankish aristocrat Luitpold of Babenberg the Bavarian eastern marches, rescued from the warring Hungarians, as a hereditary fief in 976. Elevated to a duchy in 1156 and extended by land gained along the Enns, Austria matured into a territory which held increasing significance on the southeastern edge of the German Empire. For reasons which were political and economical rather than religious, the Babenberg margraves and dukes of the terra orientalis invited a great number of monks to the country, bestowing upon them generous estates and commissioning them to clear the land. The focal point of these areas ruled by the crosier were the monasteries: Melk, Göttweig, Klosterneuburg, Kremsmünster and many others. Around 1100, a newly-erected castle in Vienna was made the new residential palace and for generations was a stop-off and assembly point for armies of crusaders from all over the world. The name »Austria« was established, with the court in Vienna acting as a mediator between East and West. The Babenberg margraves Heinrich II, Leopold VI and Friedrich II married Byzantine princesses. Along the banks of the Danube masterpieces of Middle High German literature were created;

this is where the Nibelungenlied (Song of the Nibelungen) was notated in the 13th century, where minnesingers Neidhart von Reuenthal and Reinmar the Elder from Alsace, Walther von der Vogelweide's teacher, composed and sang.

Following the demise of the Babenberg dukes, in 1278 crowned German king and Swabian Count Rudolf of Habsburg managed to defeat his adversary Ottokar of Bohemia in a battle at Marchfeld and with this laid the foundations for the future supremacy of the Habsburg dynasty. In the centuries after this, right up until 1806, Vienna was the centre and royal capital of the Kingdom of Germany in the Holy Roman Empire. By the 15th century Austrian terrain encompassed the provinces of Austria, Tyrol, Styria, Carinthia and Carniola, plus hereditary land in Swabia and Alsace. At the dawn of the modern era Emperor Maximilian I (1493–1519) and his fledglings were successful in building an empire where the sun never set, energetically engaging in the lucrative politics of marriage. Through his betrothal to the daughter of Charles the Bold, Maximilian gained Burgundy and the wealthy Netherlands; his son, Philip the Fair, was married to Johanna of Aragon and Castille, which brought the Habsburgs Spain, the affiliated Sicily, Sardinia and Naples and land overseas in the recently-discovered continent of America. Maximilian's grandson Ferdinand was finally able to secure his right to the throne of Bohemia and Hungary by wedding the sister of King Ludwig of Hungary.

In 1683, the Turks' march of triumph on the West finally halted before the gates of Vienna. The recapture of other areas of southeast Europe which had spent centuries under Muslim rule is inextricably linked to the name of a French nobleman in the service of the Habsburgs, Prince Eugene of Savoy (1663–1736). The period of war with the Saracens had transformed the Austrian crownlands into a cosmopolitan empire, into a state based on the concept of a supranational Catholic Occident, unifying many different races and cultures under the personal alliance of the Habsburg emperors in much more than name alone.

AUSTRIA OLD AND NEW

Once the wars with Turkey were over, Humanism and the Counter-Reformation of the 18th century paved the way for the flowering of the baroque in Austria. The age of Maria

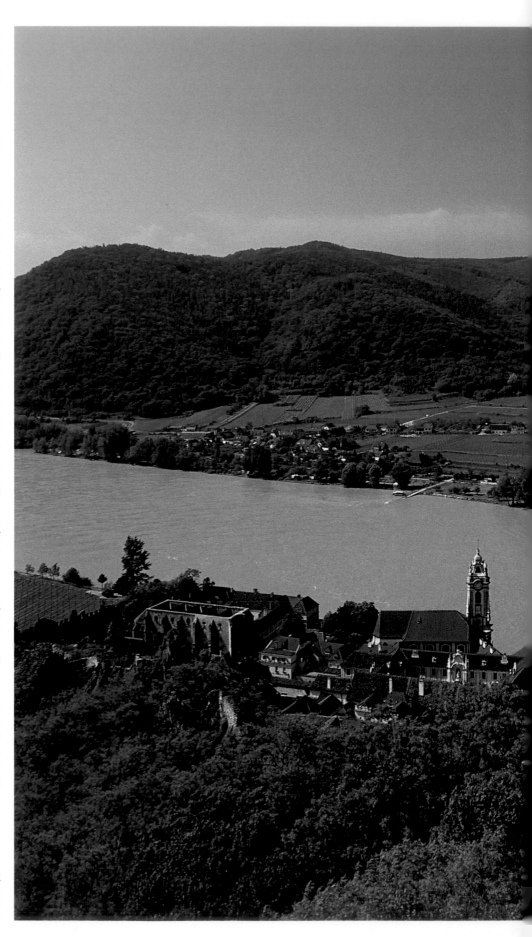

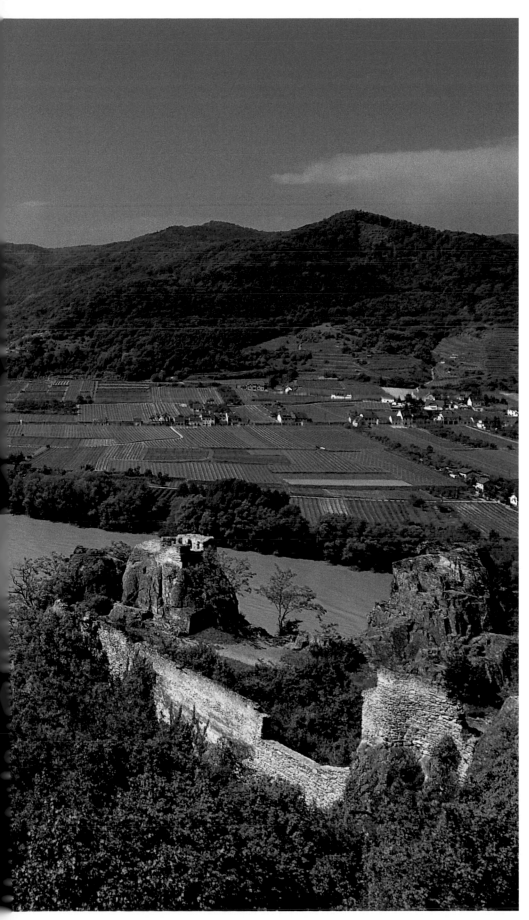

From the ruined castle of Dürnstein there are fantastic views of the little town in the Danube Valley. Duke Leopold V held Richard the Lionheart, king of England, prisoner at the castle in 1193, only releasing him after receiving a ransom of 150,000 silver marks.

Theresa still lives on in the architectural arrangements lining numerous market places and city squares, in the magnificent basilicas with their onion domes dotted across the country from Tyrol to Siebenbürgen. A baroque fondness for vivid imagery and colourful self-portrayal at parades, processions and passion plays has helped mould Austrian country life and traditions to the present day.

Once the notions of the French Revolution had begun to infiltrate the consciousness of the people of Europe, with nationalism one of the driving political forces of the 19th century, the complex organisation of the Danube monarchy was increasingly forced to take a defensive stance. Emperor Franz II's abdication from the imperial German throne in 1806 was the first indication that change was imminent. The German crown shunned, Franz II henceforth called himself the emperor of Austria. His »iron chancellor« Metternich violently refused to move with the times and was thus obliged to resign in the throes of the Revolution of 1848. The army and generals loyal to the emperor fought bloody battles and earned a period of reprieve for the monarchy as a whole, yet were not able to quell the thoughts of rebellion instilled in the minds of the public. During the reign of Emperor Franz Joseph (1848–1916), which lasted 68 years, the doctrine of divine right and autocratic rule gradually stagnated and became the subject of ridicule. Rational politics were frequently supplanted by palace protocol and the Viennese waltz. Step by step, Austria found itself being usurped from its status as a major power. At the end of the First World War, the Austro-Hungarian Dual Monarchy silently fell apart.

What has remained of this, lending Austria many of the endearing qualities it still has today, is more or less what was to be expected following a century of nation-state predominance; the old German-speaking areas of the Habsburg empire, with the exception of South Tyrol, formed a republic in 1919, which after its unhappy episode with the Third Reich between 1938 and 1945, the price paid for neutrality, rose up from the ashes in 1955 to develop its own, specifically Austrian form of state consciousness.

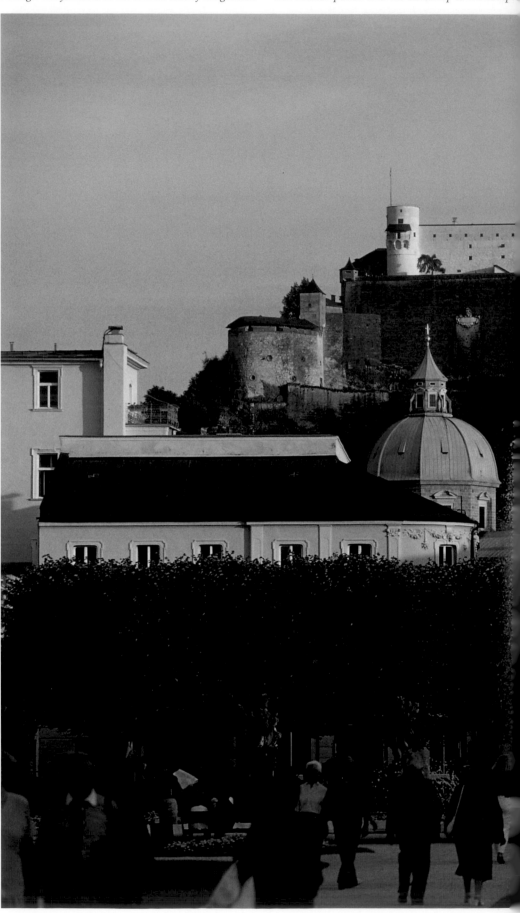

As if on display in a huge open-air arena spanning over 32,400 square miles (84,000 km2), the Habsburgs' representative centres of administration and rule lie interspersed between modern industrial parks, residential areas and rural landscapes along the Danube and in the eastern Alps. The republic has preserved its symbols of imperial central power in its castles and palaces, cathedrals, seminaries and monasteries. Each one of its provinces, of its cities and market towns continues to represent the venerable Monarchia Austriaca in its own special way.

VORARLBERG – PARADISE ON THE »SWABIAN SEA«

With its winter sports on Arlberg Mountain, one of the best ski resorts in Austria, and range of summer activities on Lake Constance, in the Bregenz Forest and up on the Alpine pastures of Montafon, Vorarlberg is a commendable holiday region. When the Flood began to abate, as the old Vorarlberg legend goes, Noah's Ark didn't come to rest on Mount Ararat in Armenia as the Bible would have us believe, but on the Widderstein summit halfway between Feldkirch and Götzis at the end of the Bregenz Forest, once alleged to have been paradise. The stretch of land, first cultivated by the Alemanni and Rhaeto-Romans and passed on to the founders of Bregenz and Feldkirch, the Counts of Montfort, after older dynasties died out in the 12th century, still has an Elysian beauty to it. Duke Leopold III procured the county of Feldkirch in 1375 and by 1523 the land stretching from »in front of« the Arlberg Pass to the »Swabian Sea«, Lake Constance, had been purchased in its entirety by the House of Habsburg. Since then it has been one of the Austrian crownlands, subject to only a brief period of non-Austrian rule.

TYROL – WIDE VALLEYS AND TALL PEAKS

Austria's most mountainous province is split into two separate areas, which for centuries formed a whole together with South Tyrol in Italy until the founding of the republic in 1919. The areas which belong to Austria are North Tyrol with the provincial capital of Innsbruck and East Tyrol with its regional capital of Lienz. From the 11th to the 13th century, former vassals to the bishops of Trento and

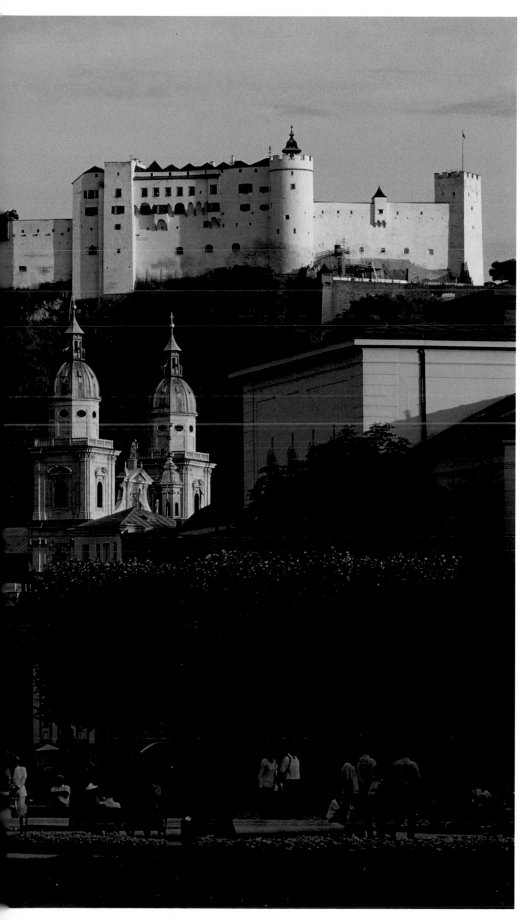

Merano, who named themselves after their castle of Tyrol near Merano, built up a worldly regime, uniting against diverse rivals – and to the detriment of the two bishoprics – to form a political unit which stretched to the River Inn. The last in line of the Meinhardinger counts, the childless Margarethe »Maultasch«, handed over her territories to Duke Rudolf of Habsburg in 1335. Maximilian I made this »princely county of Tyrol« and its royal seat Innsbruck the focal point of his empire, thus realigning it, with land which extended as far as Kitzbühel and Kufstein in the north and Ampezzo and Riva on Lake Garda in the south.

Tyrol is the ideal holiday destination for would-be mountaineers and winter sports fanatics; the latter can whiz down the glacier pistes of the central Alps all year round. Other attractions worth mentioning are the folk music, rural theatres and passion plays avidly performed in the region. Tourism and folklore play a major role here, yet Tyrol is also home to the arts, as the medieval and baroque feats of civic engineering in the old towns of Innsbruck, Solbad Hall, Schwaz, Rattenberg and Kufstein confirm.

UPPER AUSTRIA – FROM THE DACHSTEIN TO THE BOHEMIAN FOREST

Even in the very distant past Upper Austria was a region of European significance, earning recognition for the salt transported from the foot of the Dachstein Massif along ancient trade routes to the North Sea, Egypt and Africa. The place where the »white gold« of our ancestors was first mined, Hallstatt, has lent its name to an entire historical culture which, as scientists have deduced from the burial grounds found here, influenced tribes from the Viennese Forest to the Rhône, from the River Main to central Italy between the 9th and 5th centuries BC. The town of Hallstatt, squeezed into the mountainside along the shores of a lake, has been the object of tourist admiration for many years. At the foot of the snowy giants of the Dachstein Massif are the immense, awe-inspiring underground cave systems of the Rieseneishöhle and Mammuthöhle along the shores of Lake Hallstatt. The imperial Kammergut along the upper reaches of the Traun River was almost inaccessible until the 19th century, when it was discovered by artists, poets and composers. They extolled

the glorious scenery as among the most beautiful in the world, portraying it in words, pictures and music. Henceforth Upper Austria's Salzkammergut, often wrongly thought to be part of the Salzburger Land, has been one of the most popular summer holiday resorts in Austria. Each year, a fleet of festively adorned boats sails across both Lake Hallstatt and the Traunsee on the Feast of Corpus Christi.

SALZBURG – THE BEAUTY ON THE SALZACH RIVER

The province of Salzburger Land flaunts an impressive assortment of landscapes which range from the marvellous mountain panorama of the Pinzgau in the upper Salzach and Salzach valleys to the gently rolling hills and pastures of the northern Alpine foothills. Yet it's not for the scenery that many come here, but for the city which gives the province its name: Salzburg.

Salzburg became Austria's first archbishopric as early as in 798. The mining and trade of salt brought the ruling clergy prosperity, enabling them to build up an autonomous state governed by prince-bishops (the state only became part of Austria in 1816). With their love of resplendence, the archbishops in power at the dawn of the baroque transformed their royal capital into a work of art heralded across the globe. None other than the great traveller Alexander von Humboldt is said to have described Salzburg as one of the three most beautiful cities in the world.

Standing in the Mirabellgarten on the right bank of the Salzach and gazing out at the city's silhouette, you think you can understand what makes Salzburg so unique: a synthesis of nature and architecture seldom found elsewhere, the ceremonial baroque ritual of church steeples and cupolas huddled beneath the mighty fortress. Yet once you enter the old town, at best from the Staatsbrücke, the beauty of Salzburg seems to lie not in its panorama but in the muddled Gothic grid of narrow streets and squares. It is only when you look down from Mönchsberg and Hohensalzburg Fortress, however, that all is revealed; the merry medieval jumble alongside a powerful, occasionally violent ensemble of Renaissance and baroque against the backdrop of the Alps is what has elevated Salzburg to the enviable heights of one of the most beautiful cities in the world.

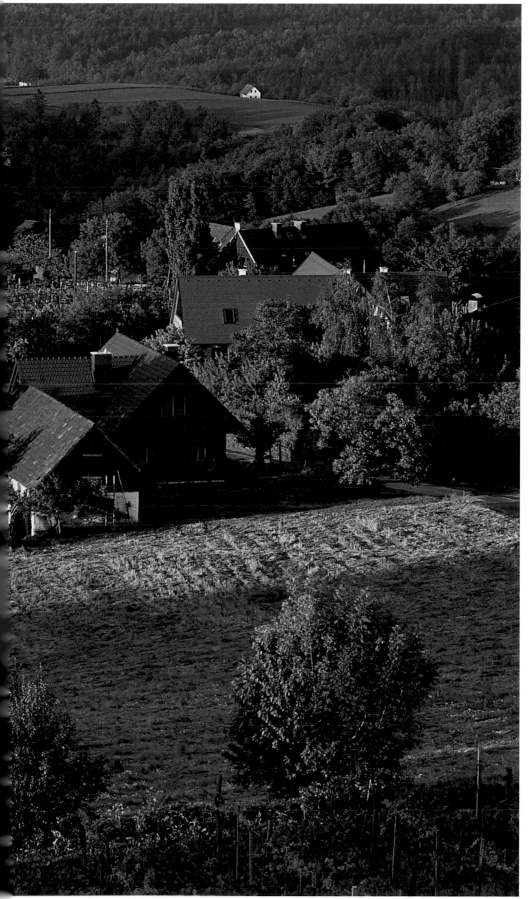

Very early on in its history the liaison of North and South made the bishopric of St Rupert a place of religious importance. A further by-product of this geographical admixture is the music of Mozart, which has brought Salzburg world fame. It's on this association of North and South that the city of music festivals and Everyman thrives to this very day.

STYRIA – GREEN HEART AND IRON BORDERLANDS

It's not without reason that Styria claims to be the »green heart« of Austria. Dense deciduous and coniferous woodland covers much of the »forest home« of poet Peter Rosegger (1843–1918) along the banks of the Enns, Mürz and Mur rivers, near Bad Aussee and Austria's most heavily frequented pilgrimage church of Mariä Geburt in Mariazell. In the midst of the lush expanse of Styria lies the famous Benedictine seminary of Admont with one of the largest and most splendid monastic libraries in the world. Undulating green hills ripple to the east of the provincial capital Graz. To the south in the Sausal region, down towards the border with Slovenia, stretch Styria's vineyards with their clattering windmills-cum-scarecrows, or Klapotetzen. Green is also the colour of the traditional Styrian loden dress, which was introduced at court and made socially acceptable by the emperor himself, Franz Joseph.

The region's second epithet of the »iron borderlands« comes from Erzberg Mountain near Leoben, one of the main sources of iron ore since the Middle Ages. Ernst »the Iron« from the Styrian line of the Habsburg dynasty was the progenitor of the two Holy Roman Emperors of Germany who secured Austria's position as a world power: Friedrich III and his son Maximilian I.

CARINTHIA – SUMMER SUN AND SWIMMING

Historically speaking, Carinthia is Austria's oldest and most esteemed region. Vienna was an insignificant church settlement when in 976 the »Carinthian marches« were separated from Bavaria by Emperor Otto II and made an independent duchy of the German Empire. Both the old and new provincial capitals of St. Veit and Klagenfurt are well worth a visit,

The communal housing on the corner of Löwengasse and Kegelstraße in Vienna was designed in 1983 by artist Friedensreich Hundertwasser (1928 - 2000)

as »an antidote to the anonymity, hostility and aggression of the concrete bunker«. As bright as a child's box of paints, the building has rounded

as is Villach, often called the »secret« capital of Carinthia. On a geographical note, Carinthia is the fifth-largest and mildest province in the Alpine republic, a land of summer with over twelve hundred lakes of all shapes and sizes in basins protected from the wind and weather on all sides, with the Carnic Alps and the Karawankas to the south and the Tauern ridge to the north. The Großglockner-Hochalpen-straße runs up from Heiligenblut (the parish church here with its carved Gothic altar and legendary Capsule of the Holy Blood is one of the province's major attractions) via Hochtor at 8,448 feet (2,575 m) above sea level into the Salzburger Land, past the longest glacier in the Großglockner Massif, the Pasterzenkees, which has a span of 6 miles (10 km).

LOWER AUSTRIA – BIRTHPLACE OF AN EMPIRE

As the name suggests, Lower Austria constitutes the lowlands of the country, with plateaux to the north and east, low mountains to the south and forest and vineyards to the north. For centuries, Avars, Huns, Magyars, Hussites, Hungarian kuruczok and Turks forged their way west across the Thaya, March and Leitha rivers and through the farmlands east of the Enns. With Vienna as its centre of power in a rather eccentric location, Austria gradually spilled across these borderlands along both sides of the Danube into the neighbouring areas. Safeguarded by the castles and fortified monasteries crowning the tops of the hills, villages, market towns and small cities began to spread throughout the valleys. The nucleus of Austria's land of origin was Melk on the Danube at the start of the Wachau. Royal capital and place of burial for the first of the Babenbergs, Melk was the birthplace of the empire to come. In Lower Austria, wherever there was a religious foundation, there was usually never a castle of command far away. Thus not far from Melk Monastery is Aggstein, seat of the mighty Kuenringer. They twice rebelled against those in power, first the Babenbergs then the Habsburgs, twice losing their estates and positions at court. In the far east of the province, towering above gentle hills at the confluence of the Thaya and March and the beginning of the Moravian Basin, ruined Falkenstein Castle was erected in 1050 to protect the empire from attacks from the East.

...rners, windows of different sizes and trees and ...shes planted on the roof and verandas.

VIENNA – MORE THAN JUST THE WALTZ

Almost everybody knows something about the Vienna of the waltz, horse-drawn carriage and coffee house. The other sides to Vienna – and there are many – are less well-known. Paris stands for France, London for England, Berlin is the epitome of Prussia, yet right from the beginning Vienna was Europe, the only truly European city on the Continent: seat of the Holy Roman Emperor of Germany, royal capital of a multiracial nation and of the Austrian empire, for which there was no binding constitutional form, and home to the Viennese, many of whom have such mixed origins that they are often not actually Viennese at all. The most popular cliché of someone from Vienna is that of a leisurely but also rather belligerent whinger who can't enjoy anything without having a good grouse about it – with the exception of music, a good Papperl (»feast«) and wine. He is often parodied as being his greatest enemy, unable to live without his wine and his Viennese compatriots; immortalised by cabaret artist Helmut Qualtinger as »Herr Karl«, this is someone who can't stand his fellow citizens yet holds anyone in contempt who dares to insult them. The Viennese local, with at least one parent from one of the former crownlands, forced to coexist with a number of different traditions for centuries, is often torn between at least two modes of existence, on the one hand genuinely endeavouring to consolidate the various standpoints of his life »in a human fashion« – and always a little sceptical in doing so – yet never actually responsible for anything.

The best first impressions of what was the most easterly major city in the Western world of the 13th and 14th centuries are to be had in the old town huddled around Steffl, St Stephen's Cathedral. Here in this »inner city« and beyond it, beyond the boundaries of the bastions long gone, is baroque Vienna, are the palaces of architects Fischer von Erlach and Lukas von Hildebrandt, climaxing in the magnificent Schloss Belvedere, the summer residence of Prince Eugene which is a work of art in itself. Here, too, is the Ringstraße, over two miles (4 km) long, lined with the splendid buildings which still seem to represent the imperial, constitutional monarchy of the 19th century.

BURGENLAND – A PIECE OF AUSTRIA-HUNGARY

As the name would suggest (Burg being German for castle), there are indeed plenty of castles in the Burgenland, with some of them (Forchenstein, Schlaining and Bernstein, for example) even quite impressive in size. Yet the area wasn't named after its fortresses but after the four urban centres and administrative districts in German West Hungary, Preßburg, Eisenburg, Wieselburg and Ödenburg, the latter first mentioned in 800. The modern province was created in 1921 from the German-speaking areas along the Hungarian border which were given to Austria under the Saint-Germain peace treaty of 1919. Not just the name, but also the people and the region they live in are reminders of a close historical and neighbourly association with Hungary. The reedy wilderness of Lake Neusiedler, a steppe lake otherwise only found in Central Asia, is home to many species of bird not common in Central Europe, with storks, grey herons, avocets and plovers wading through the warm salt pools. Arms of pumps and wells punctuate the horizon of this puszta landscape around the Seewinkel. In the land which Turkish armies once used as their sally port to the West, Hungarian magnates invited German settlers to build a life for themselves. Thus alongside the expected strains of Hungarian and Croatian, you can still hear snippets of an old Swabian dialect and an ancient version of Bavarian which the poets of the Nibelungen-lied could have spoken. Eisenstadt, Austria's newest provincial capital, contains the grave of Joseph Haydn, composer of over a hundred symphonies and the melody to the German national anthem, which was originally the song of imperial Austria proclaiming »God save our emperor...!«

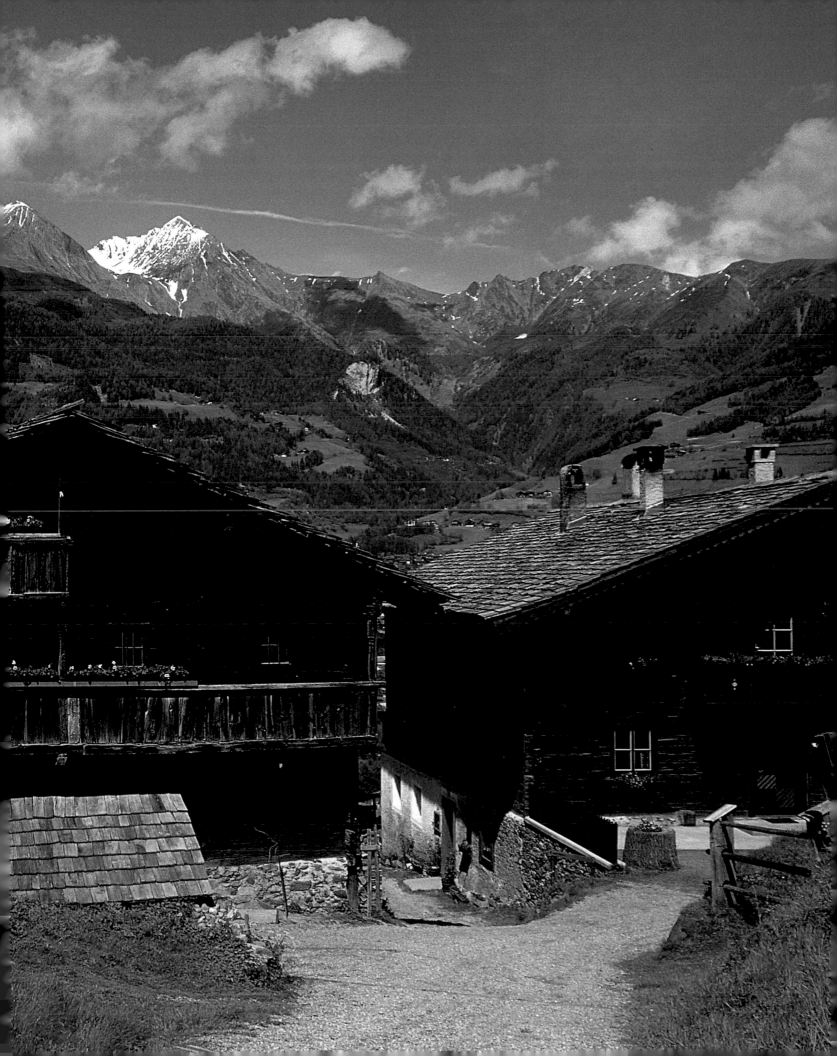

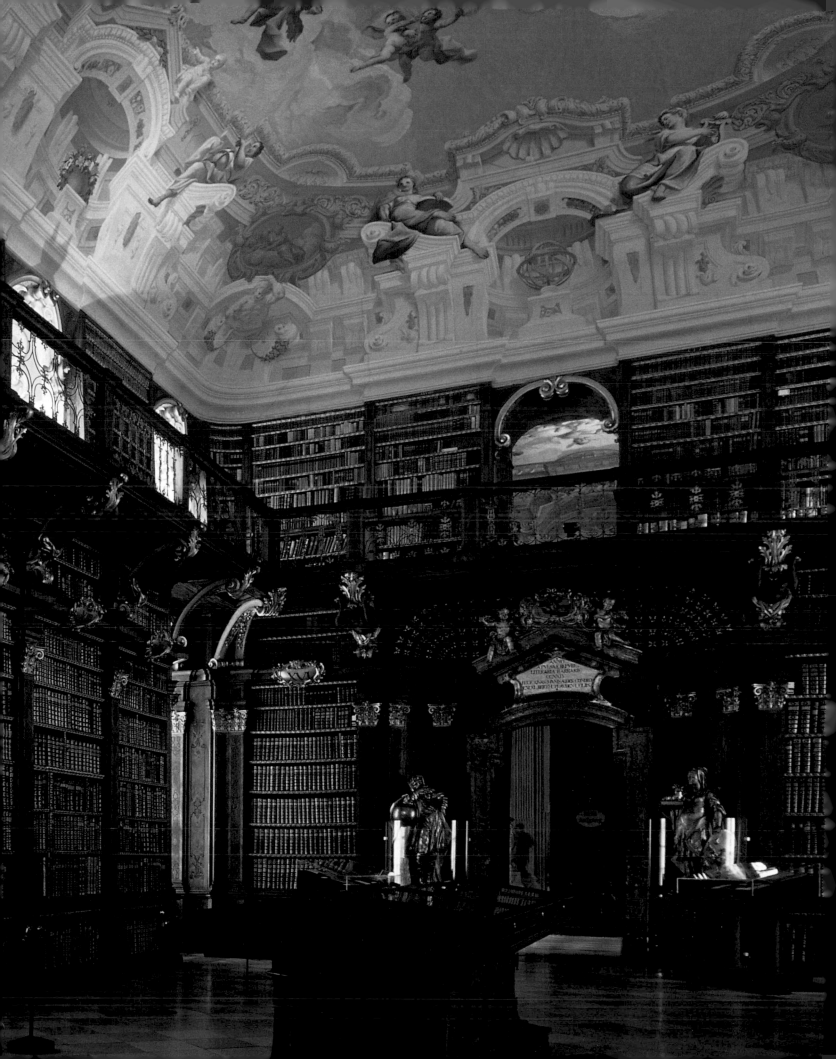

Ellmau at the foot of the Wilder Kaiser is not just popular with winter holidaymakers. In summer, the jagged peaks encircling the three crags of the Ellmauer Haltspitze (7,690 ft/2,344 m) are an El Dorado for mountaineers and climbers.

The area between serene Lake Constance and the glacial ice of the Hohe Tauern with Austria's highest and most famous mountain, the Großglockner (12,458 ft/3,797m), is a land of gentian and edelweiss, of chamois and marmots. Like the Alemanni, the people of Vorarlberg are extolled as being hardworking, very respectable and conscious of tradition. Visitors from all over the world flood to Bregenz with its international lakeside festival and to the medieval towns of Feldkirch and Bludenz. Running south from the floor of the Rhine Valley at Lake Constance, the little province climbs more than 9,000 feet to the pinnacles of the Silvretta range over a stretch of just 50 miles. On the smooth white slopes encircling St. Anton am Arlberg is where a century ago the first hobby skiers made their slithering descent.

The winter resorts clustered around Arlberg Mountain are mirrored by famous names in Tyrol: Zillertal, Ötztal, Stubaital, Kitzbühel and St. Johann, Seefeld and Lermoos. The world of snow-capped peaks, gnarled forests and roaring mountain streams away from the densely populated valleys of the Ill, Inn and upper Drava is, however, something which has been unscrupulously tampered with for far too long. In the Middle Ages, the county of Tyrol was a pivot in European exchanges between North and South – and still is. In the 16th century, the »land in the mountains«, rich in mineral resources, helped lay the foundations of power for the new Habsburg potentates. The chic salt and mining towns in the Inn valley, Schwaz, Rattenberg and Hall with their noble town houses, bear witness to an age of former greatness. During the reign of Emperor Maximilian I (1493–1519), »Golden« Innsbruck was the royal seat of an empire in which the sun was never to set.

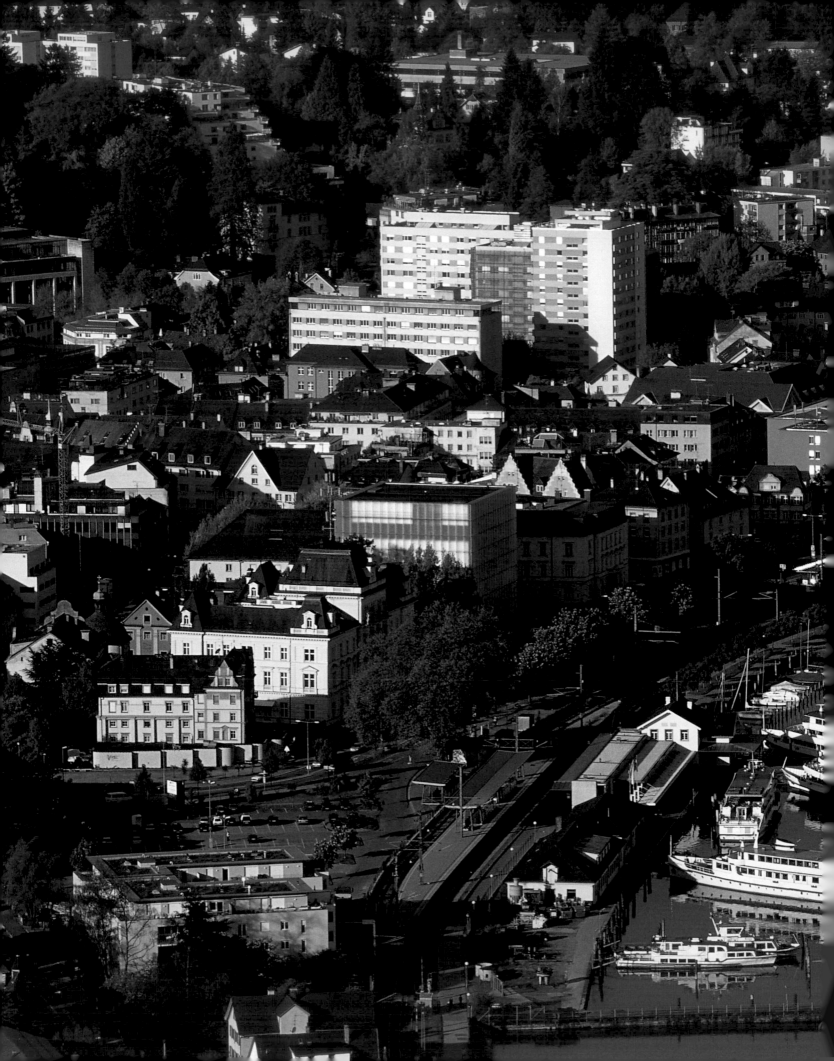

Left:
Pleasure boats leave the harbour at Bregenz for trips across Lake Constance

Below:
Ruined Hohenbregenz Castle crowns the steep, rocky spur of the Gebhardsberg. The panoramic view out over the town, Lake Constance and the Rhine Valley attracts many visitors.

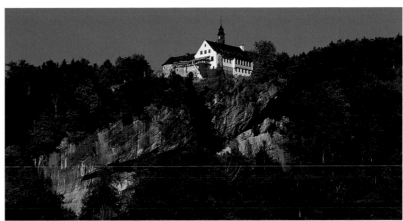

Above centre:
The history of Bregenz's Oberstadt with its pretty houses goes back to the late Roman fort of Brigantium and a Celtic refuge.

Left:
The mighty 14th-century Martinsturm is Bregenz's local landmark. 1599 to 1601 heralded the arrival of the baroque in the Lake Constance area, when the onion dome of the tower was built.

Below:
The idyllically situated
pilgrimage church near
Götzis in the Rhine
Valley is dedicated to

St Arbogast. A cycle of
panels from 1659 in the
nave tells the story of
the Strasbourg bishop's
life.

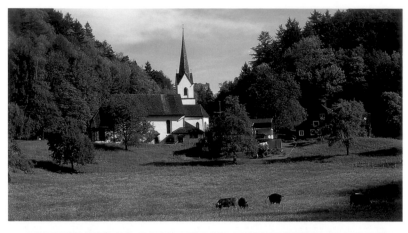

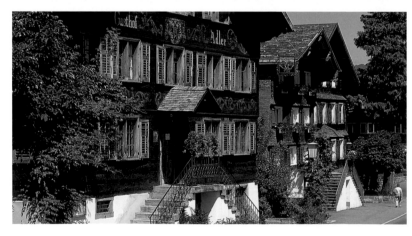

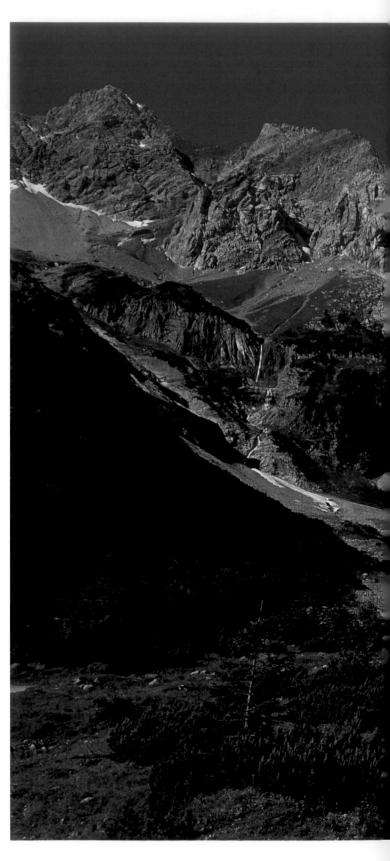

Above centre:
The Bregenz Forest rail-
way was closed in 1980.
The steam train is now a
tourist attraction shunt-
ing enthusiasts between
Berzau and Bersbuch.

Above:
Schwarzenberg is one
of the most traditional
villages in the Bregenz
Forest. It has a number
of inviting ancient inns,
such as the Adler, built
in 1757.

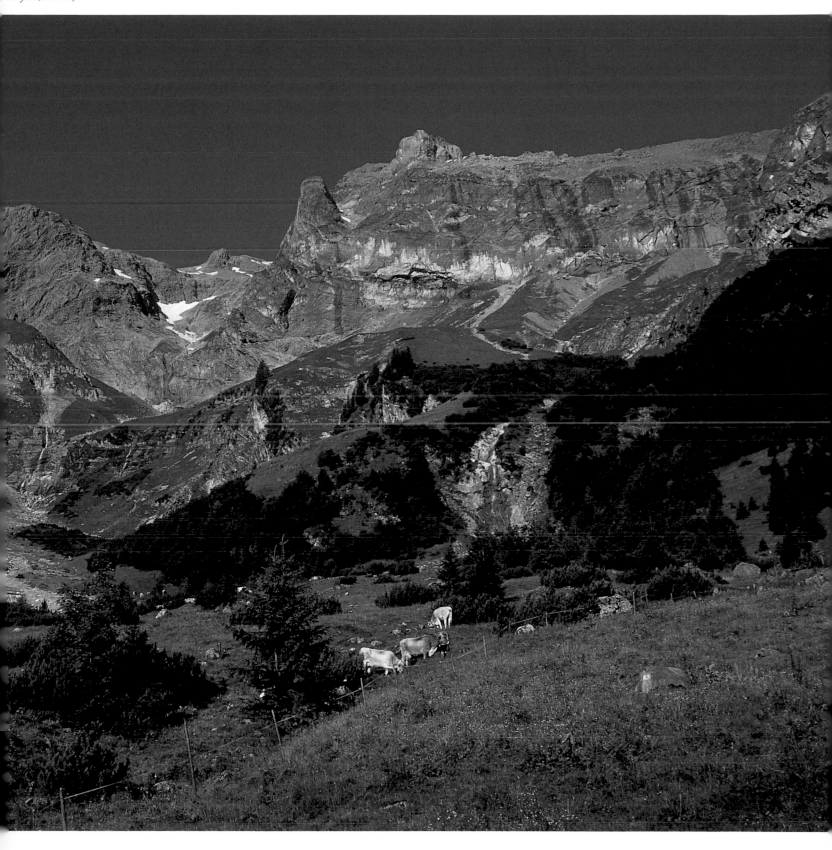

*e bulky mountains backing the Brandnertal are
ninated by »queen of the Rätikon« Schesaplana
728 ft/2,965 m).*

Below and right:
The ski resorts on Arlberg Mountain are said to be where the sport originated. The region is named after the old mountain pass between the Rhine and Inn valleys. This is where in 1901 the first ski club was founded and the first downhill runs were staged. Winter sports centres Lech (below) and Zürs on the Vorarlberg side and St Anton and St Christoph (right) on the Tyrol side of the mountains offer a vast number of pistes and runs.

Left:
If you're tired out after a hard morning's skiing on the Galzig (7,169 ft/2,185 m) near St Anton, why not grab some lunch at the restaurant or simply soak up some sun?

Below:
The slopes of the Valluga, St Anton's local mountain (9,223 ft/2,811 m), have excellent pistes for expert skiers. From the summit station at Vallugagrat there are impressive views out across snowy peaks.

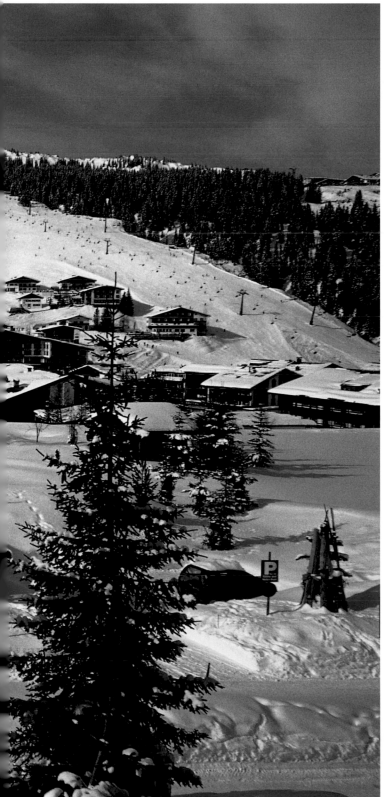

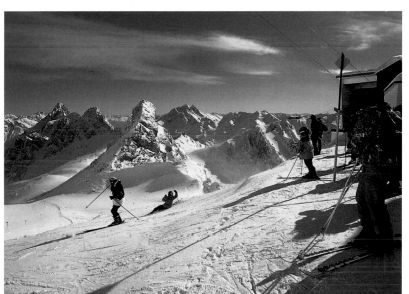

Above:
An alcoholic Jagertee in the snow is just what you need for that last downhill run and to put you in the mood for some après-ski.

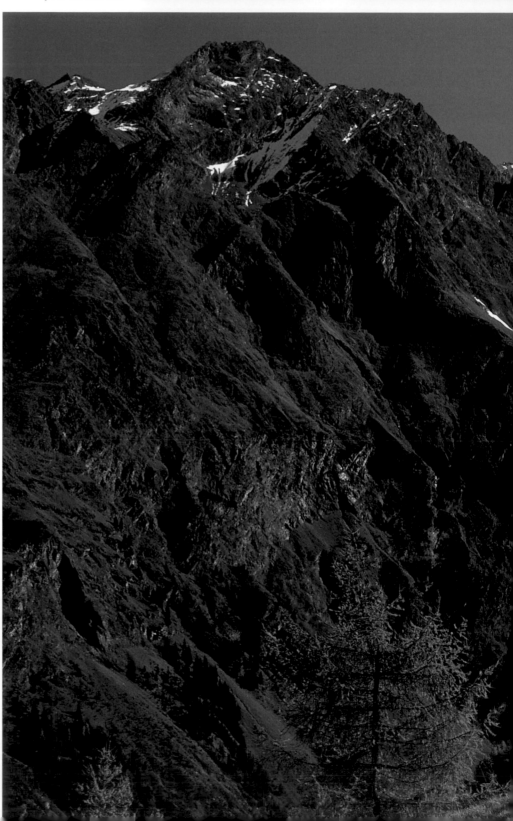

Below and left:
Alpine pastures like the Arzler Alm in the Pitztal (below) fulfil an important ecological function. Constant grazing prevents erosion of the soil. The flowers adorning the animals on their way back down from the high meadows (left) indicate that all have returned safely.

Page 36/37:
Pertisau, tucked into a corner of the Achensee, is where mountain tours commence of the Karwendel Range with its steep scree slopes and precipitous drops.

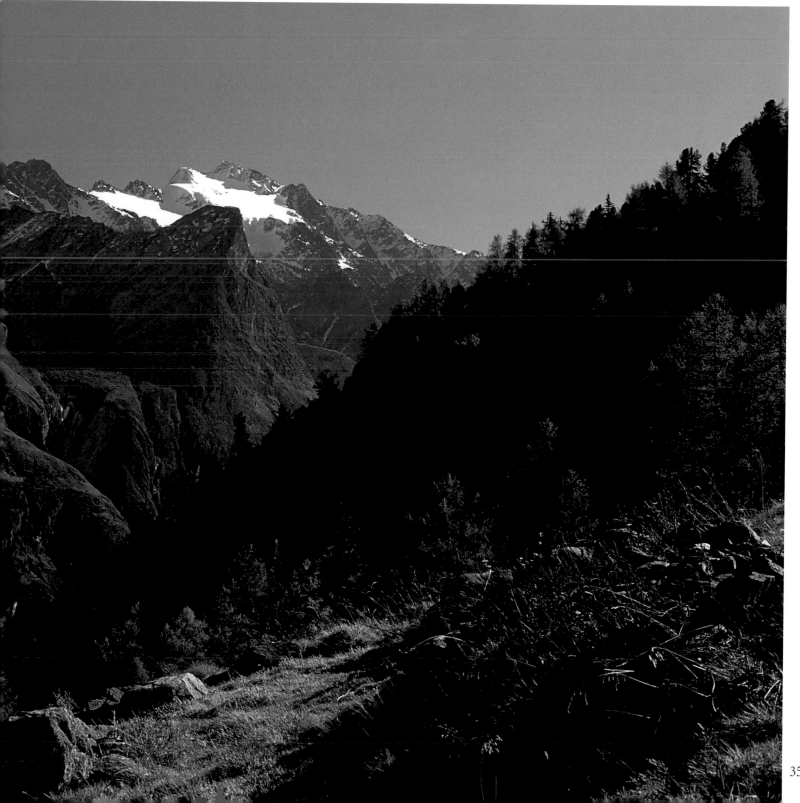

Three popular films from the 1950s have made Austrian empress Elisabeth something of a cult figure. In the minds of German-speakers across Europe, actress Romy Schneider and the historic Sissi have become one, elevated to the highest ranks of the collective myth. Yet if we put the clichés aside, behind the façade of the popular monarch we will discover one of the most interesting and complex women of the 19th century.

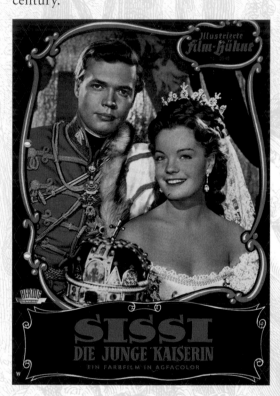

Young Emperor Franz Joseph's first meeting with fifteen-year-old Sissi in a summer resort in the Salzkammergut has become legend. In the privacy of a villa in Bad Ischl in 1853, the emperor's mother Sophie had arranged for her son to meet his future bride Helene, the eldest daughter of Duke Max in Bavaria. As many know, things didn't go as planned. Helene's girlishly delightful younger sister, who had come along to the family rendezvous, captured the emperor's heart from the first moment on. For Franz Joseph it was love at first sight, a love which was to last his lifetime. Whether the bewildered teenager, struck by the first

Left:
In the filmed version of the Sissi story, Romy Schneider and Karlheinz Böhm enact a tale of romantic love. In real life the empress was terribly insecure and unhappy, long before she was married to her fiancé.

LEGENDARY EMPRESS

ght:
e oil painting and
otograph of Empress
sabeth are from 1865
d 1868, executed at
e height of her beauty
t. A decade later she

wrote: »There's nothing
more dreadful than
slowly being turned into
a mummy«.

pangs of lovesickness, really knew what she was letting herself in for, we shall never know. »You don't turn an emperor down!« is allegedly the advice offered by her mother Ludovika. A year later, the magnificent wedding took place in Vienna.

For Sissi, who had spent an untroubled childhood in the idyllic stately home of Possenhofen on Lake Starnberg, the strict protocol at court in Vienna and the endless regal duties she had to perform were a torment from day one. She came to hate Vienna's »prison castle« more and more. Although the behaviour expected of her at court and by her mother-in-law was the source of many problems, in the first years of marriage her relationship with Franz Joseph was good. When in later years her love for him had faded, she wrote melancholy verses in memory of these happier times.

The dreamy young empress, intimidated by the pomp and ceremony of the royal household, gradually built up her self-confidence. During the 1860s, the timid, cautious Sissi blossomed into a woman famed for her beauty all over the world. Yet her physical assets were to become the subject of an almost unhealthy obsession. Behind the unapproachable, comely mask she hid her loneliness and insecurity. Several hours each day were spent styling her hair.

Sissi began to go her own way relatively early on in her imperial career. Her frequent absences from court and her puzzling illnesses were the cause of agitation and never-ending gossip in the circles of the nobility and aristocracy. In October 1860 she was in such a poor state of health following nervous disorders and fierce dieting that she was forced to spend time recuperating on the island of Madeira. After being back in Vienna for just four days, however, her bouts of coughing and fever again became serious. She then spent almost a year enjoying the solitude of Corfu and Venice. This pattern of permanent escape was to shape the rest of her unsettled life. The stuffy ceremony and regimental atmosphere of the Hofburg and Schloss

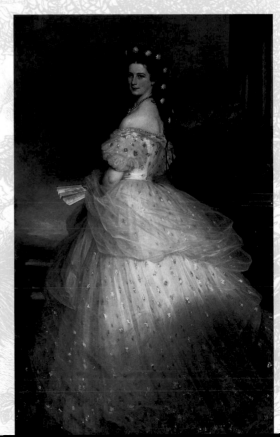

Schönbrunn in Vienna had literally made the publicity-shy monarch ill.

Her aversion to Viennese society was not the only major factor in Elisabeth's life. She also held sympathies towards Hungary, which since the Revolution of 1848 had been treated as a rebellious, troubled province. Although she was thought to have no gift for languages, within a short space of time she learnt to speak fluent Hungarian. When in the 1880s she developed a love for Greece, building an Achilles palace in marble in Corfu, she applied herself to ancient and modern Greek with similar enthusiasm.

Elisabeth spent the last years of her life in transit, travelling the length and breadth of Europe. Her final port of call was Geneva, where in 1898 she was stabbed in the heart by an Italian anarchist on the shores of the lake. With all her inconsistencies she is remembered as a surprisingly modern woman who tried to free herself from the bonds of prejudice which constrained her social class. It is thus all the more tragic that in trying to unfold her true self she became permanently imprisoned by the obligations of her role as empress.

Today, Kitzbühel (right) is a chic sports centre. Not many people know that the town owes its evolution to mining, as does Schwaz in Tyrol (centre right), which has managed to retain its historical character.

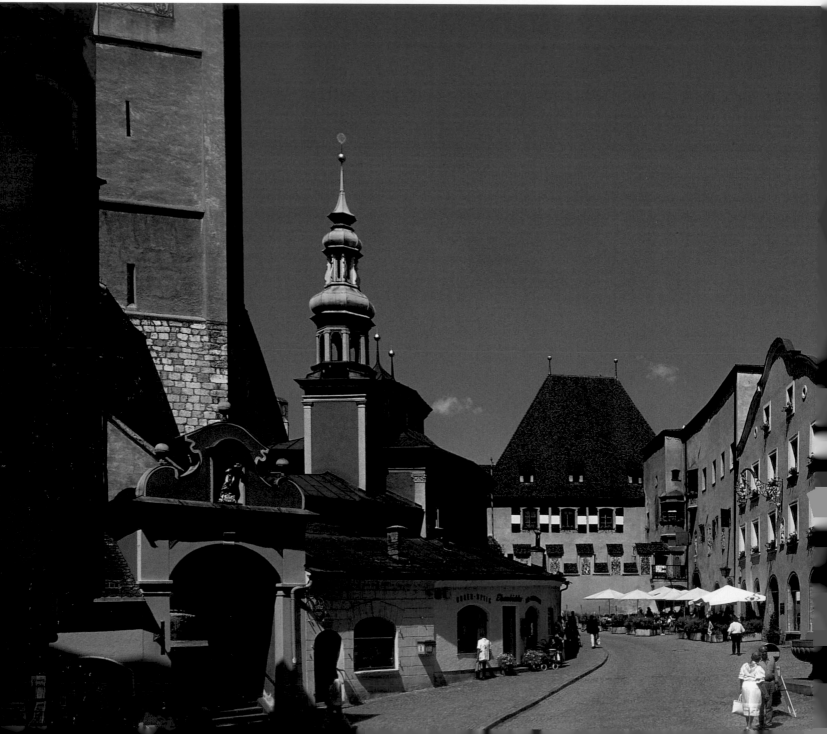

Below and left:
At the end of the Middle Ages, salt mining gradually brought prosperity to Hall in Tyrol. The tall façades of the old town (left) and the upper market place (below) testify to the financial confidence of its burghers.

Top right:
Giant Tratzberg Castle towers high over the Inn Valley near Jenbach. The castle was rebuilt as a Renaissance palace following a fire. In the 16th century it belonged to the Augsburg patrician families Ilsung and Fugger.

Centre right:
Rattenberg was granted its town charter as early as in 1393. Its proud town houses were constructed during the silver mining boom of the late Middle Ages. Today, with a mere ca. 600 inhabitants, Rattenberg is the smallest town in Tyrol.

Bottom right:
Kufstein Fortress controlled the principle access to Tyrol along the narrow Inn Valley gorge. It wasn't until after the Landshut War of Succession in 1504 that Emperor Maximilian I was able to seize the castle from the dukes of Bavaria.

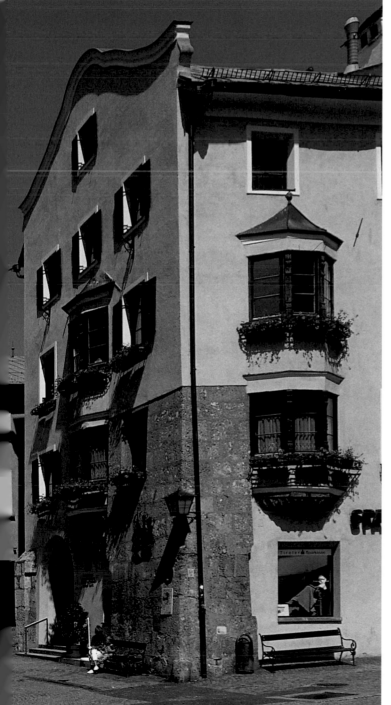

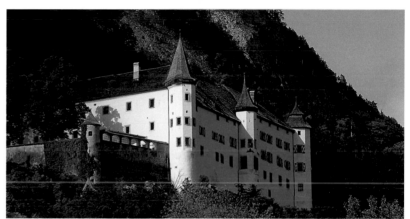

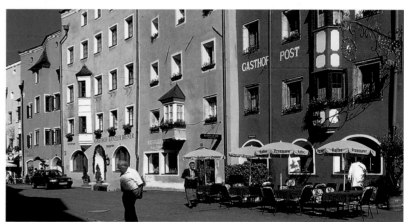

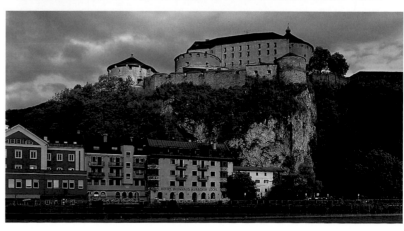

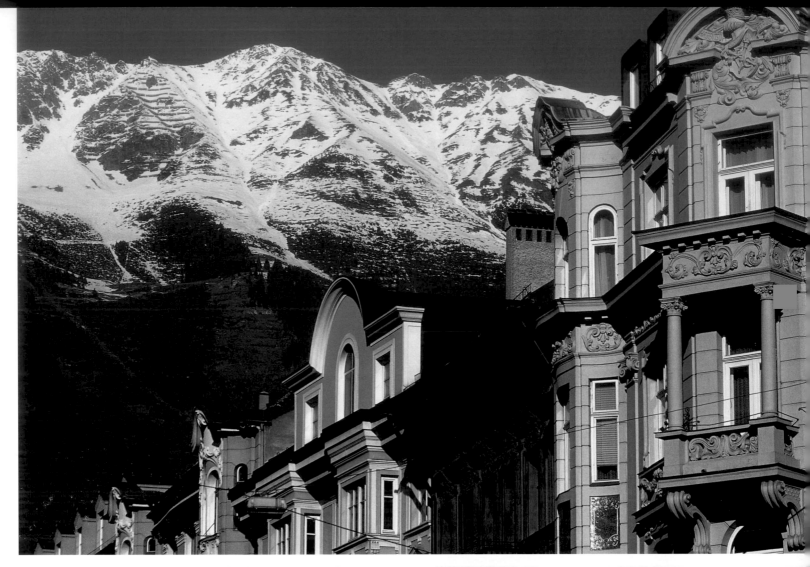

Top:
The Maria-Theresien-Straße with its splendid buildings is the main artery of the Tyrolean capital. From the north, the snowy summits of the Karwendel Range peer down on the baroque façades.

Lukas Cranach the Elder created the picture on the high altar of what was the Innsbruck

parish church of St Jacob's in c. 1530. The church was made a cathedral in 1964.

The local term for the larger-than-life bronze statues on the grave of Maximilian I in

Innsbruck's Hofkirche is »the black men«.

42

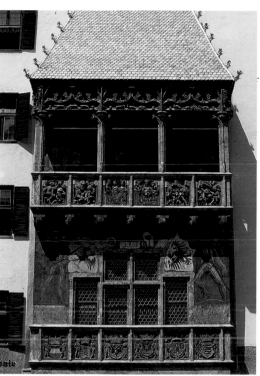

Below:
Emperor Maximilian I had the Golden Roof erected on the main city square in Innsbruck.

Select spectators could watch public festivals from the comfort of the ornate oriel with its gilded copper shingles.

Below and left:
From the parapet of the Stadtturm there are giddy bird's-eye views of the streets of Innsbruck (below). Nearby is the Helblinghaus (left), which with its magnificent stucco front is one of the most beautiful Rococo buildings in town.

Below:
Carnic Dolomitenstraße leads away from the raw climes of the Alps into milder pastures. Ancient granaries in Obertilliach mark the beginning of the zone where corn is cultivated.

Below centre:
At Matrei in East Tyrol the Virgental cuts off to the west. Above the little church in Bichl, the Venediger Group beckons to friends of ecological tourism.

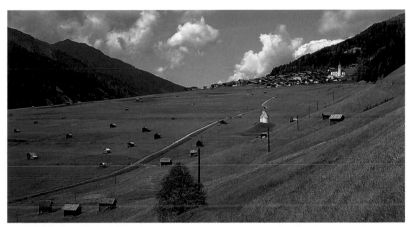

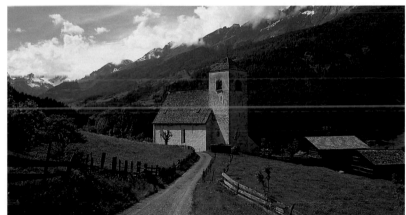

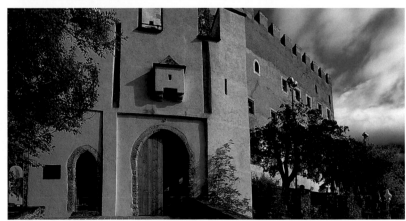

What is now East Tyrol was in the hands of the counts of Görz until the 16th century. Schloss Bruck (left and above) *on a wooded rise above regional capital Lienz was their ancestral home.*

45

One of the most popular places near the spa town Bad Ischl is, and has long been, Katrinalm. There are grand views of the Dachstein Massif from the adjacent Kaiser-Franz-Joseph-Kreuz.

North of the Danube, the mysterious Mühlviertel is smothered in dark forests of raw beauty which spill over into Bohemia. Towards the south, the area around the River Enns, with its main town of Linz, slowly ascends from the fertile plains of the Innviertel, Austria's »granary«, to the picturesque lake district of the Salzkammergut. The salt mined here was for a long time one of the region's principle sources of wealth. One of the oldest sites where this »white gold« was found is Hallstatt at the base of Hoher Dachstein Mountain (9,856 ft/3,004 m).

The cultural centre of the Salzburger Land is, as the name would lead us to believe, Salzburg, the former seat of the prince-bishops. The city of Mozart is a successful ensemble of medieval, Renaissance, baroque and Rococo architecture. Salzburg's Alpine foreland with its idyllic mountain and lake-side scenery on Lake Fuschl and Lake Wolfgang slides into the famous Salzkammergut.

South of the main ridge of the Alps expanses of forest cover almost half of Styria; its other half is a patchwork arrangement of meadows, lowland and highland pastures and vineyards. Styria is also mountainous, yet the only precipitous inclines and glaciers to be found here are in the lower reaches of the Dachstein Massif, towering above the ski resort of Schladming. The provincial capital of Graz also has a Southern flair to it, with a charming old town which provides the setting for a yearly festival of the avant-garde, the Steirischer Herbst.

Embedded between the main ridge of the Tauern in the north and the Karawankas and the Carnic Alps in the south is the sheltered basin of Carinthia, Austria's warmest, southernmost province. Lake Wörther and the resorts on the Ossiacher and Millstädter See are among the most popular of the 1,270 bathing lakes.

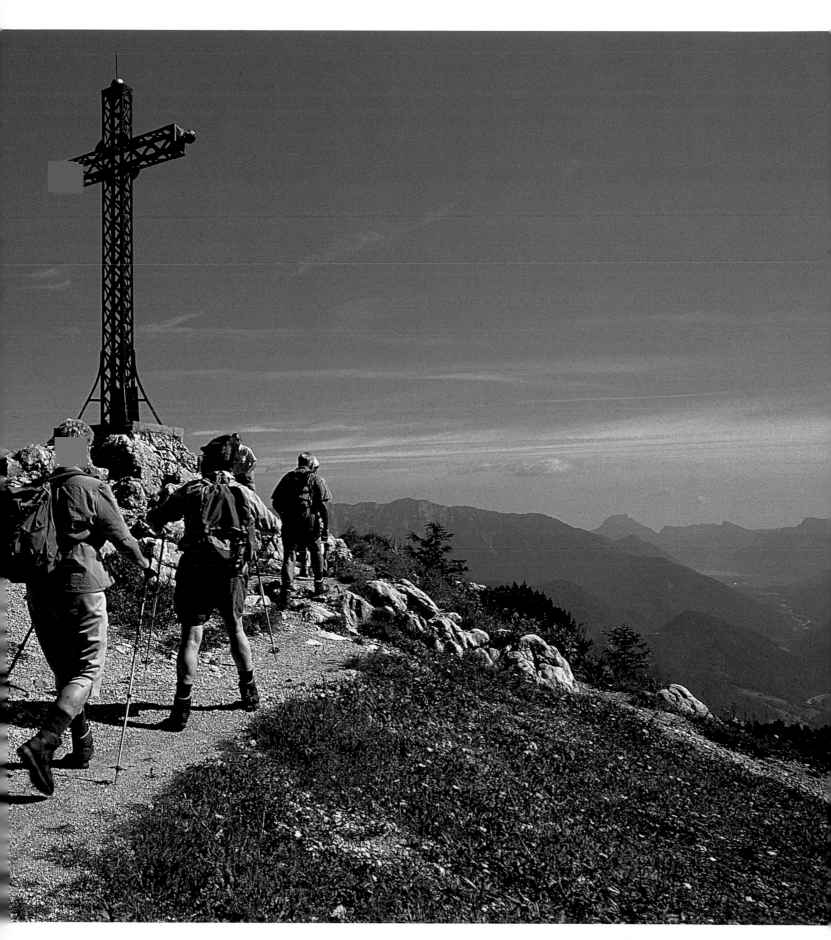

Below:
The imperial villa in Bad Ischl witnessed the first meeting between Emperor Franz Joseph and Sissi in 1853. Archduchess Sophie gave the then rented house to the young couple as a wedding present.

Below centre:
In the park at the villa in Bad Ischl Elisabeth had a »marble palace« built in 1869, where she could go to be alone and think. The pavilion now houses a photographic museum.

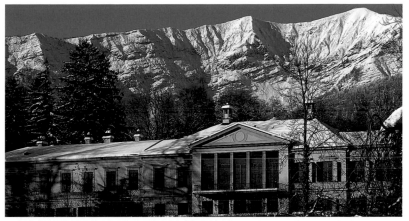

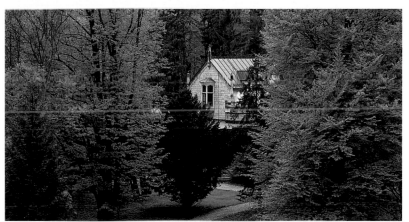

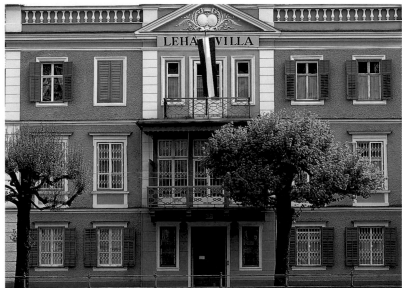

Left and above:
Composer Franz Lehár lived from 1912 until his death in 1948 in a lavish villa in Bad Ischl (above). His study (left), where he wrote 24 of his operettas, can be visited as part of the present museum.

Right:
*Each year on 5 January
the Glöcklerlauf festival
is held in Ebensee at the
southern end of the
Traunsee. The symbolic
lights of the procession
are an old heathen
custom.*

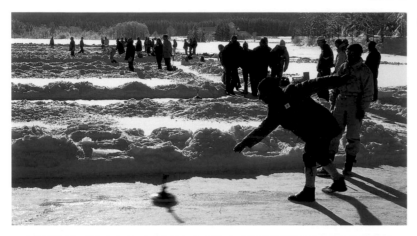

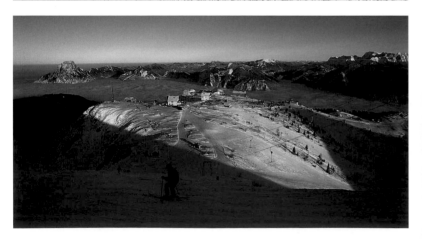

In winter the Arcadian Almsee (above centre) at the foot of the Totes Gebirge is frozen into a solid slab of ice. For curlers (top) this marks the start of the hottest season in their year. The aim of this Alpine game is to get the curling stone as close to the tee as possible. High up above the clouds the first skiers enjoy the morning sun atop Feuerkogel in the Salzkammergut (above). Only those with local knowledge can make out the Traunsee in the valley.

Below:

At Corpus Christi the waters of Lake Hallstatt host a very colourful spectacle. Accompanied by flags and music, the procession across the lake has all the cere- mony of baroque folk worship. Festively decorated rowing boats surround the canopy covering the tabernacle with the Blessed Sacrament.

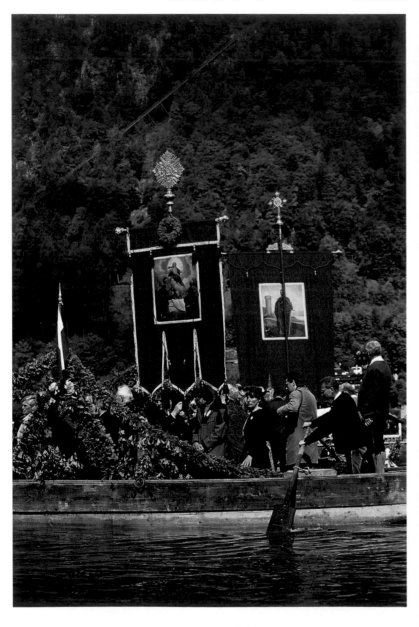

Right:

Until well into the 19th century, the only way to reach Hallstatt was along narrow mule tracks or by water. Boats were also used to pass from house to house crowded along the shores of the lake. Finds from the early Iron Age have lent their name to an entire epoch, the Hallstattian Age (800–400 BC).

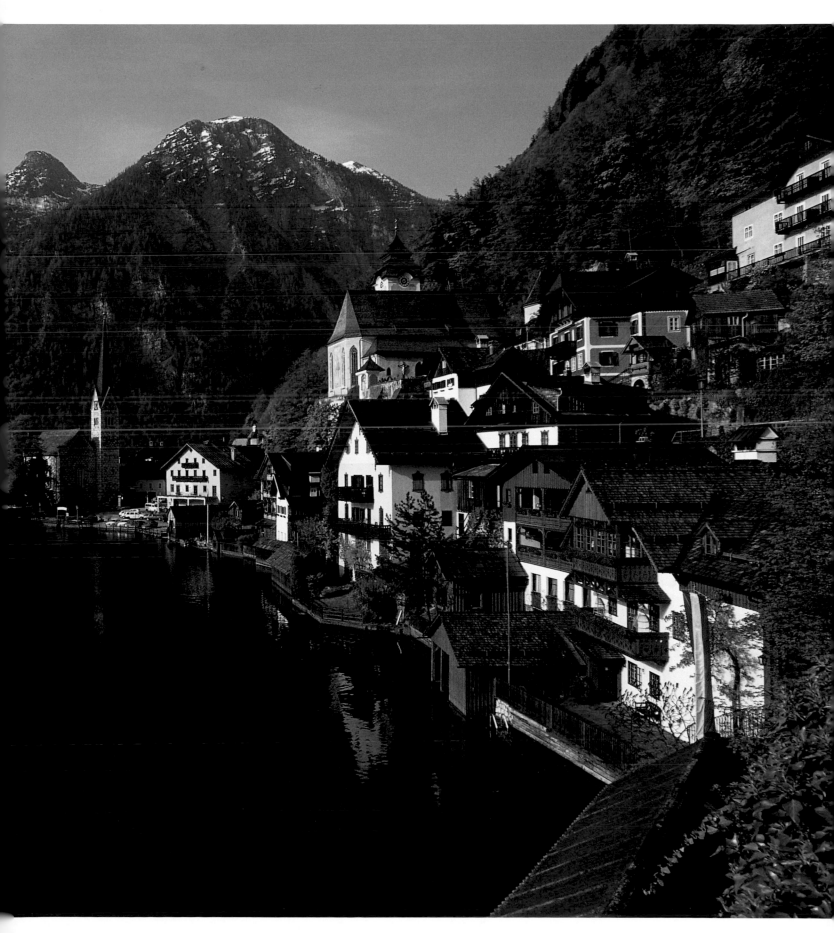

Right:
Composer Gustav Mahler (1860–1911) occasionally lived and often worked in this tiny house in Steinbach on the Attersee.

Below:
The Mondseer Rauchhaus open-air museum gets its name from the old farmhouses without chimneys exhibited here (»smoke houses«). Mondsee village on the lake of the same name stages a music festival in the first week of September each year.

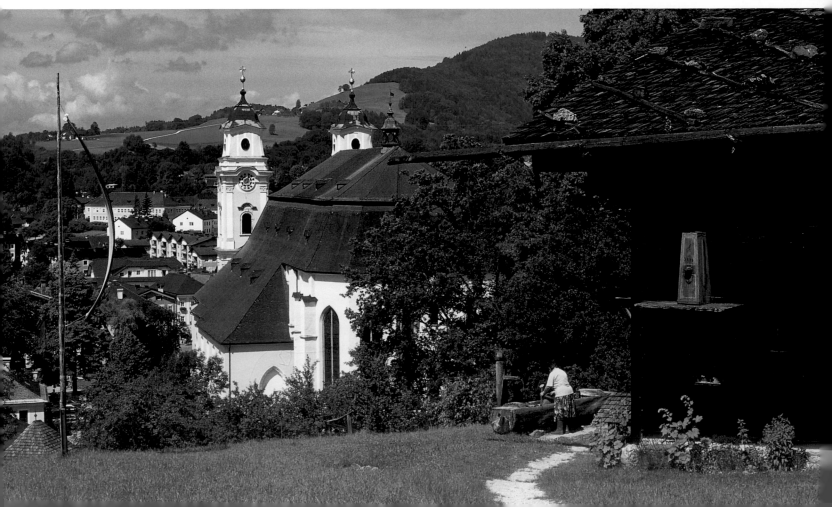

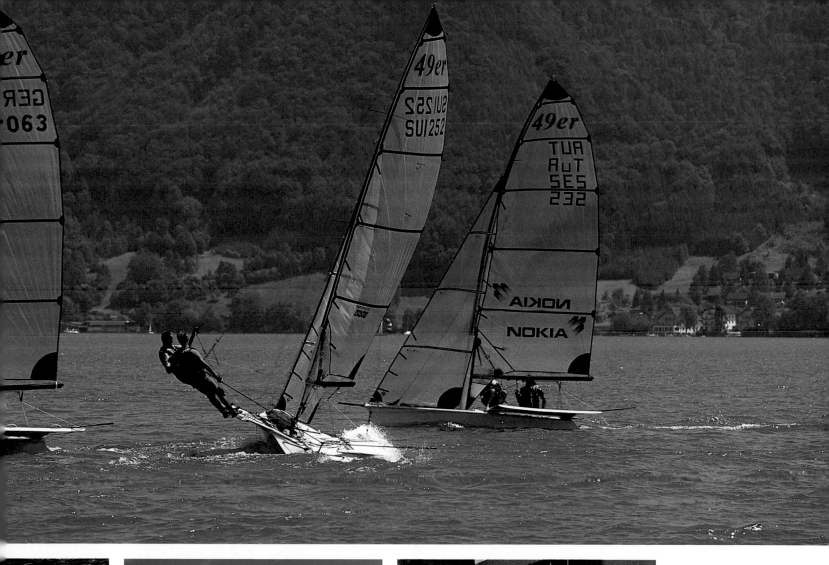

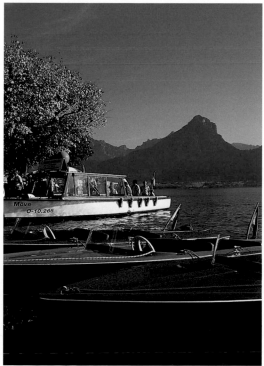

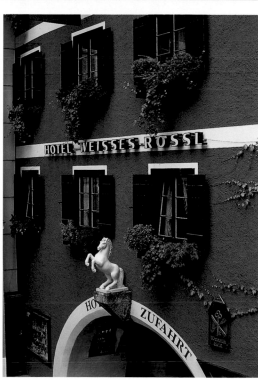

In summer the lakes of
the Upper Austrian
Salzkammergut, here
Attersee, are inundated
with yachtsmen (above).
For the less sporty there
are plenty of pleasure
boats (left).
The Weißes Rössl on
Lake Wolfgang (right)
rose to fame through an
operetta written by
Ralph Benatzky.

Page 56:
...htenstein Castle on ...right bank of the ...ube is mentioned *as being a county seat in 1097. It's one of the approximately 40 palaces, castles and* *ruins dotted between Passau and Linz.*

Sleepy and peaceful, the tranquil Obermühl curves along the wooded banks of the River Danube, whose wide bends form the boundary between the Innviertel to the south and the Mühlviertel to the north.

Excellently trained teams of horses compete with their masters in Altenfelden in the Mühlviertel to see who's the best at the ancient art of carriage driving.

Page 58/59:
The Tennengau is seen at its best from the Post-almstraße. When the buttercups and rose-root are in flower on the summer meadows, the Dachstein is still white with the last snows of winter.

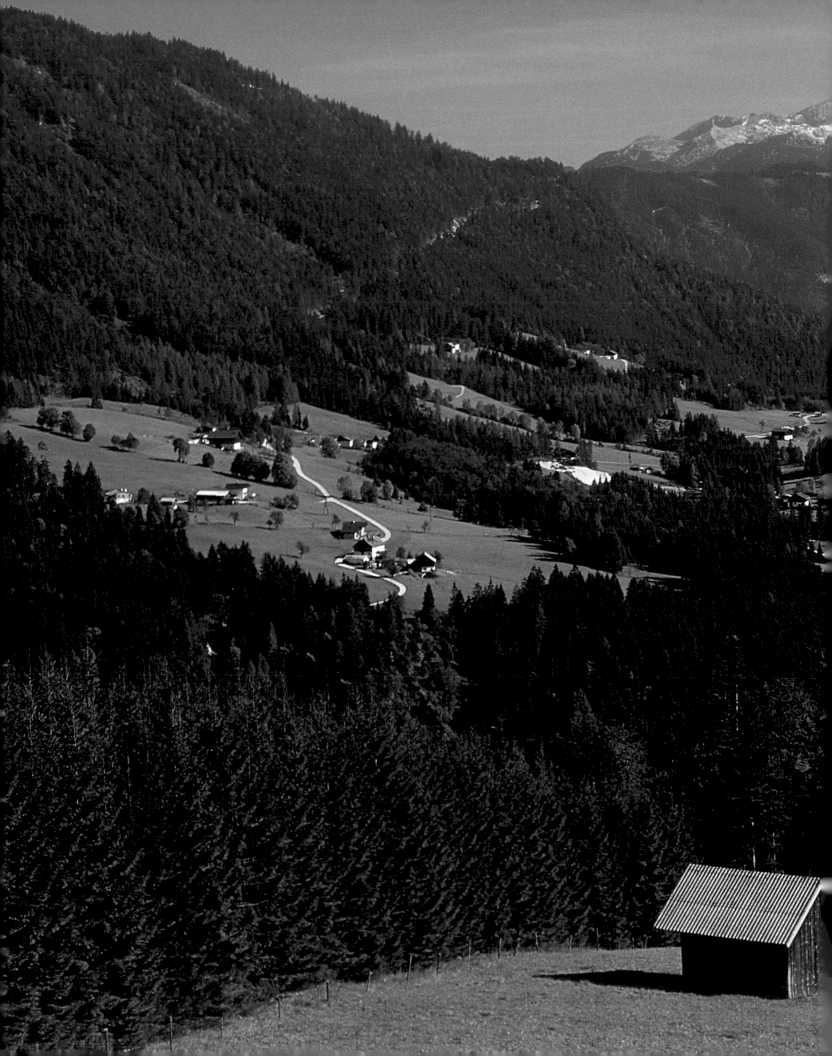

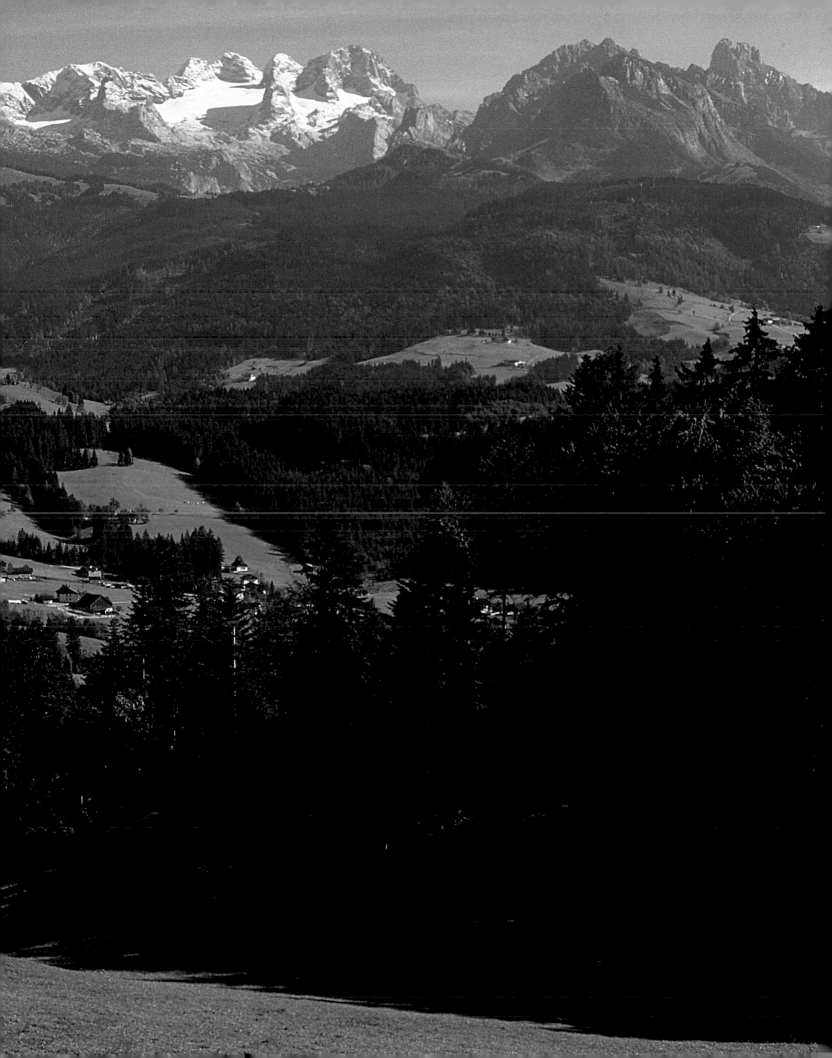

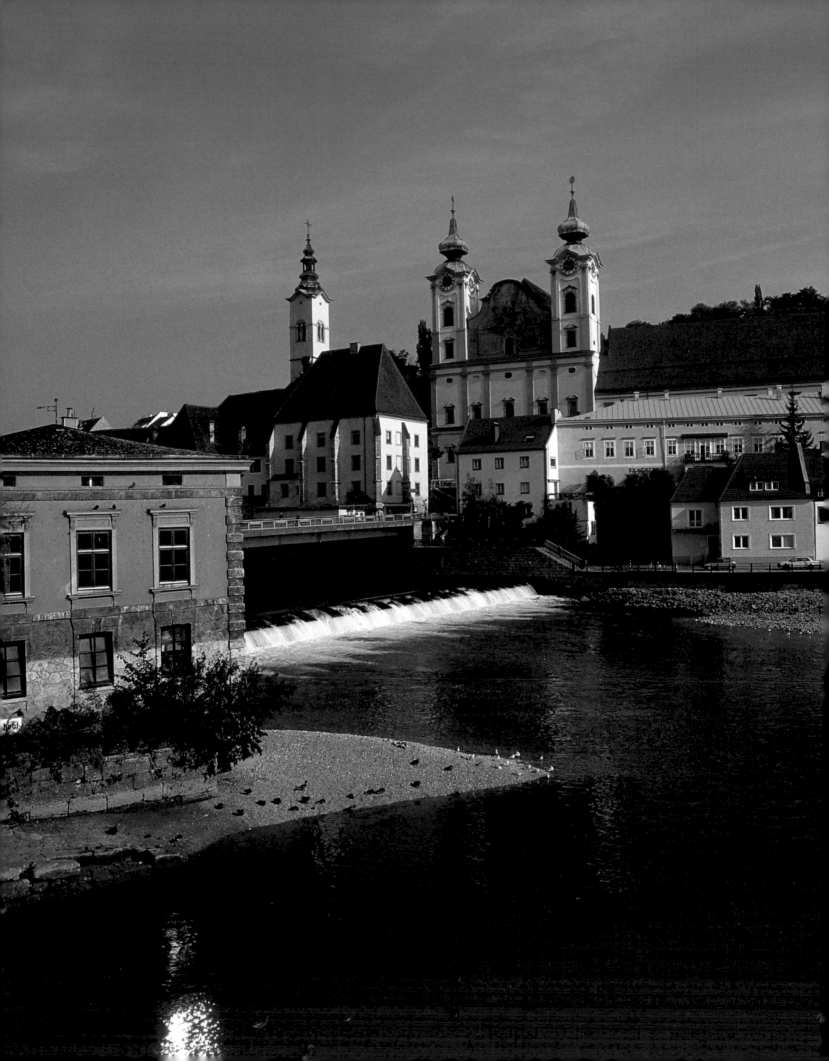

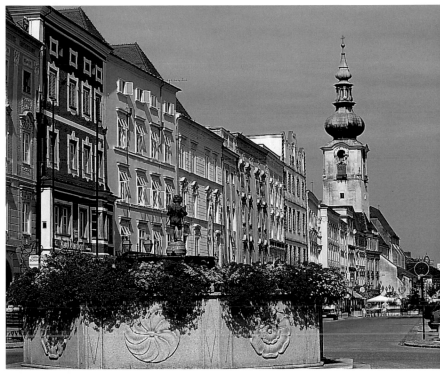

Left and bottom left:
The Benedictine monastery of Kremsmünster (left) is one of the oldest and most important in Austria. Baroque arcades (bottom left) festoon the fishponds where fish were kept for Lent.

Below:
With its wonderful town houses, the main square in Wels (below) is one of the finest in the whole of Austria.

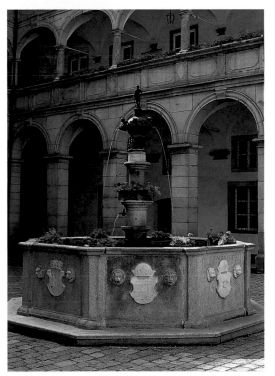

60:
...dustrial iron town of Steyr grew up around the ...f the Steyr and Enns rivers. The parish church ...Michael's and the old hospital church dominate ...rth bank of the confluence.

Above centre and above right:
The Landhaus in Linz is the seat of government for Upper Austria. The courtyard surrounding the octagonal Planet Fountain is a venue for gala concerts. A few streets on, the accomplished tones of splendidly dressed buskers fills the air.

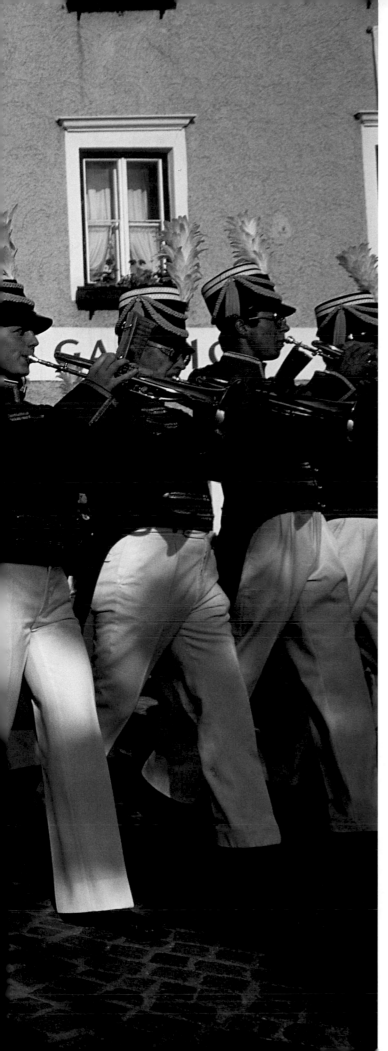

In Salzburg's Lungau the biblical figure of Samson is the main player in a number of colourful processions. Tamsweg (left) and Mauterndorf (below) are the strong-holds of the cult focussing on the muscle man of the Old Testament. Ancient chronicles record Samson plays being performed in Tamsweg in the baroque period. The notion of dressing the giant in Roman armour (bottom) allegedly came from the Capuchins in Mauterndorf.

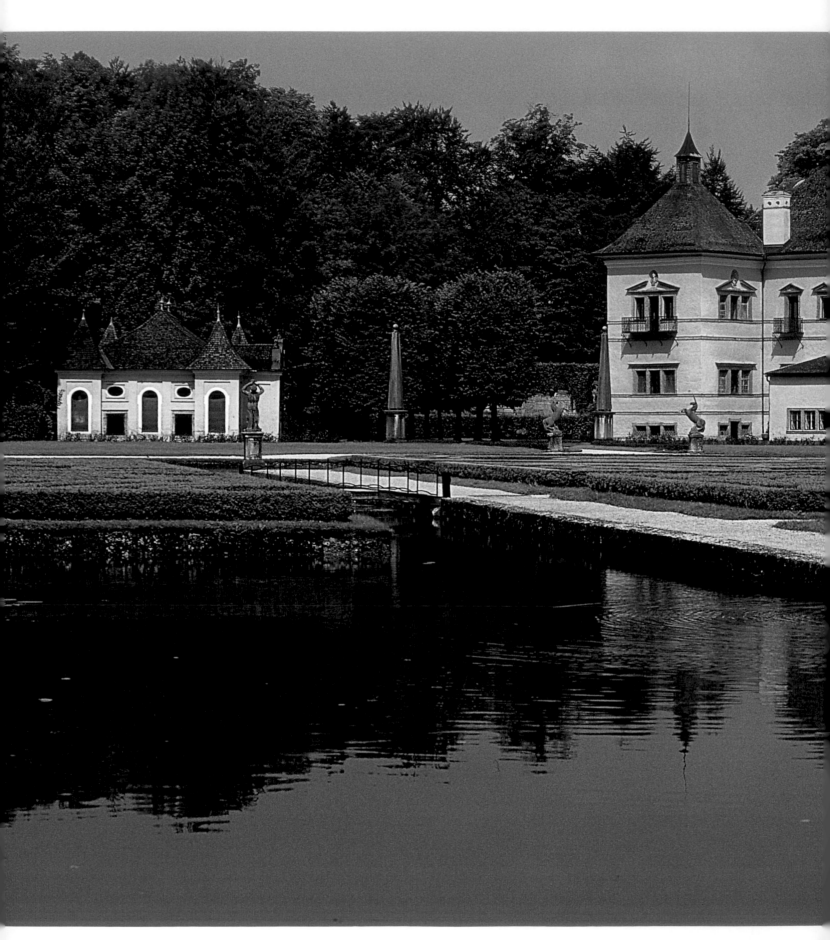

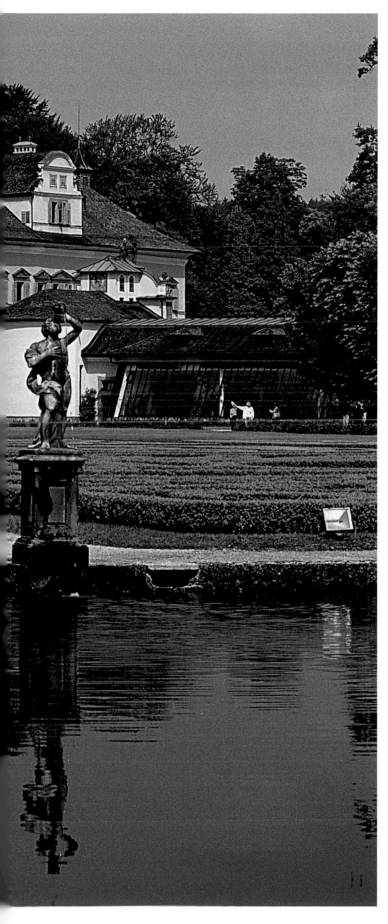

The pilgrimage church of Maria Plain is a good hour's walk from Salzburg. Wolfgang Amadeus Mozart dedicated his »Krönungsmesse« to the picture of the Virgin from 1657, said to have miraculous powers.

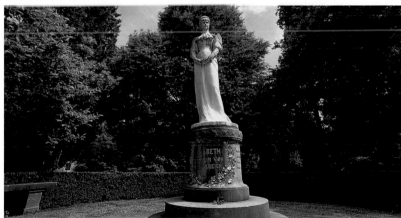

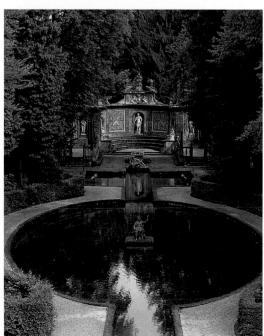

Schloss Hellbrunn (left page) was built between 1612 and 1615 in the early baroque style as the summer seat of the Salzburg prince-bishops. In the expansive park stands a statue of Empress Elisabeth (centre) and a Roman theatre (bottom).

. . . **is** a suitably sugary ode to a sugary dish, the famous Salzburg Nockerln or soufflé which for many gourmets is the epitome of the Austrian dessert. Straight out of the oven, often dribbled with a delicious sauce and dusted with icing sugar, it's hard

to detect the lowly origins of the strudel, Tascherln, Buchteln, Nockerln and the like, whether baked or boiled; these sweet temptations all start out as a very simple mixture of flour and water.

In its raw state, the dough doesn't exactly promise epicurean delights. Yet at the hands of an expert cook, armed with a battery of tried-and-tested recipes, the dough becomes a smooth, workable mass from which sublime dainties are formed. Milk, eggs and butter are not used sparingly. With or without yeast, enriched with all kinds of tasty additions, such as cinnamon, lemon and currants, and often filled with select titbits, the ennobled mix is then usually arranged on a baking tray and slid into the oven. Served warm, with a crunchy topping or icing sugar and often in a creamy sauce flavoured with poppy seeds or vanilla, these dough delicacies are either served as a filling main course or are the grand finale to a sumptuous feast.

The variations on puddings prepared in the frying pan are no less numerous. Schmarren, an pancake shredded with a fork, was originally a simple peasant dish made of milk and millet, which over the centuries has risen to become one of the star attractions of Austrian cuisine. It reaches perfection as golden yellow Kaiserschmarren, sweetened with sultanas and plum jam. The story goes that the slithers of pancake fried in copious quantities of fat were »invented« when a young girl, dreaming of her lover, absently let the Schmarren dough drip into hot lard. The doughnut family is no less prolific and includes Liwanzen, which, as the name would suggest, originated in Bohemia. Liwanzen are small yeast buns fried in fat which are tastiest served with Powidl (plum jam) and icing sugar.

The family of desserts also includes a bewildering range of dumplings which are served as accompaniments to meat dishes or – surprise, surprise – as sweet courses. One of the latter which is particularly well-known and popular is the yeast Germknödel with ground poppy seeds or the Marillenknödel with its apricot filling and breadcrumbs tossed in butter. Knödel gets its name from Kugel, yet in Austria it takes on shapes and designations which to the uninitiated don't always give immediate clues as to its true identity. The Servietten- or Palffyknödel, a sausage of bread or yeast dough, comes in slices and is usually eaten as a side dish with a thick sauce. The idea of steaming a fat roll of dough in a napkin is a Bohemian one which rapidly made its way onto the tables of Danube city restaurants.

»Bohemian« lady cooks (most of them actually came from Moravia) enjoyed legendary status in the imperial Vienna of the turn of the 19th century. They merrily enlarged their local repertoire with recipes from other Habsburg crownlands to produce dozens of mouth-watering permutations, many of which still have their original Bohemian names; Dalken, Buchteln, Kolatschen, Grammelpogatschen, Powidltaschkerln and Palatschinken have become fixed features in the seventh heaven of Austrian sweets.

Another typical (and edible) protégé of the Danube monarchy is the successful Apfelstrudel. The wafer-thin pastry is said to come from the Turks and the Hungarians

Left:
Buchteln are a yeast dough with a delicious filling and sauce made of vanilla, poppy seeds, sultanas or quark.

AS GENTLE AS A KISS... «

Below:
...fenpalatschinken has
absolutely nothing to
...ith Schinken (ham).
...n close to, it reminds
of its poor cousin the
...ncake, although this
delicacy is baked in the
oven and has a tasty
quark or Topfen filling.

Right:
The Topfenknödel made
of rolls and quark is
boiled in salted water.
The Powidl (plum jam)
which goes with it is of
Bohemian origin.

provided the apples, but it was the Viennese who added the final polish with sultanas, cinnamon and chopped nuts. If the apples are replaced by apricots which have been stoned and halved, you have a Wachauer Marillenstrudel. Quark or curd, native to the Alpine regions, is a major ingredient of the Topfenstrudel. A typical dish and top favourite of old Vienna is the Millirahmstrudel with its tasty bread filling. This is served with »canary milk«, a milky sauce dyed pale yellow with pods of vanilla.

Salzburger Nockerln
(serves 4)

Ingredients:
6 egg whites
A pinch of salt
3 tbsp sugar
1 packet of
vanilla sugar
3 egg yolks
20 g (1 oz) flour
Grated rind of
1 untreated lemon
4 tbsp milk
20 g (1 oz) butter
2 tbsp icing sugar

Bring the milk and butter to the boil in a flat, flame- and oven-proof

casserole. Spoon in the meringue mixture, making pyramids (Nockerln). Bake for ca. 10 minutes until golden brown in a preheated oven (220°C/425°F/gas mark 7). The Nockerln should be creamy inside.

Take out of the oven and sprinkle with the icing sugar. Serve immediately, as otherwise the soufflé will collapse.

Whisk the egg whites and salt until stiff, gradually adding the sugar and vanilla sugar. Mix the beaten egg yolks with a third of the whisked egg whites. Carefully fold this mixture into the remaining meringue, gradually adding the sieved flour and grated lemon rind.

Getreidegasse (right page) is still one of the main shopping streets in Salzburg. At number 3 the co-founder of Germany's Social Democratic Party, August Bebel, worked as a turner's apprentice in 1859/60. Number 9 (below left) is where Wolfgang

Amadeus Mozart was born on 27 January 1756. The people of Salzburg have proved far more enterprising than the impoverished composer. In 1890 confectioner Paul Fürst named his marzipan, pistachio and nougat chocolates Mozartkugel (below right).

In Salzburg there's also a Mozart square, a Mozart bridge, Mozartwochen and Mozartfestspiele music festivals and even a Mozart liqueur, not to mention the many cakes and pastries which bear his name (Mozartecken, Mozartsterne, Mozarttaler...)

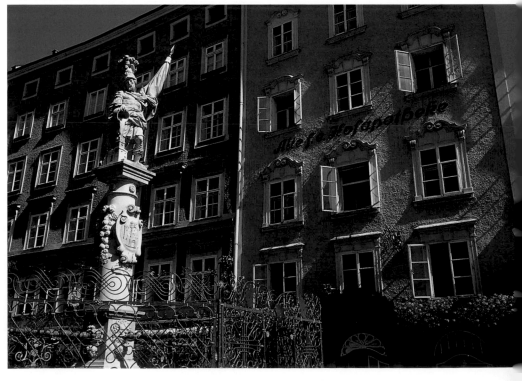

The Salzburg Festspiele were launched by Hugo von Hofmannsthal and Max Reinhardt in 1920. The undisputed highlight is the yearly performance of »Everyman« on Domplatz.

The figure of St Florian on the Alter Markt fountain in Salzburg points to the traditional court apothecary of the prince-bishops.

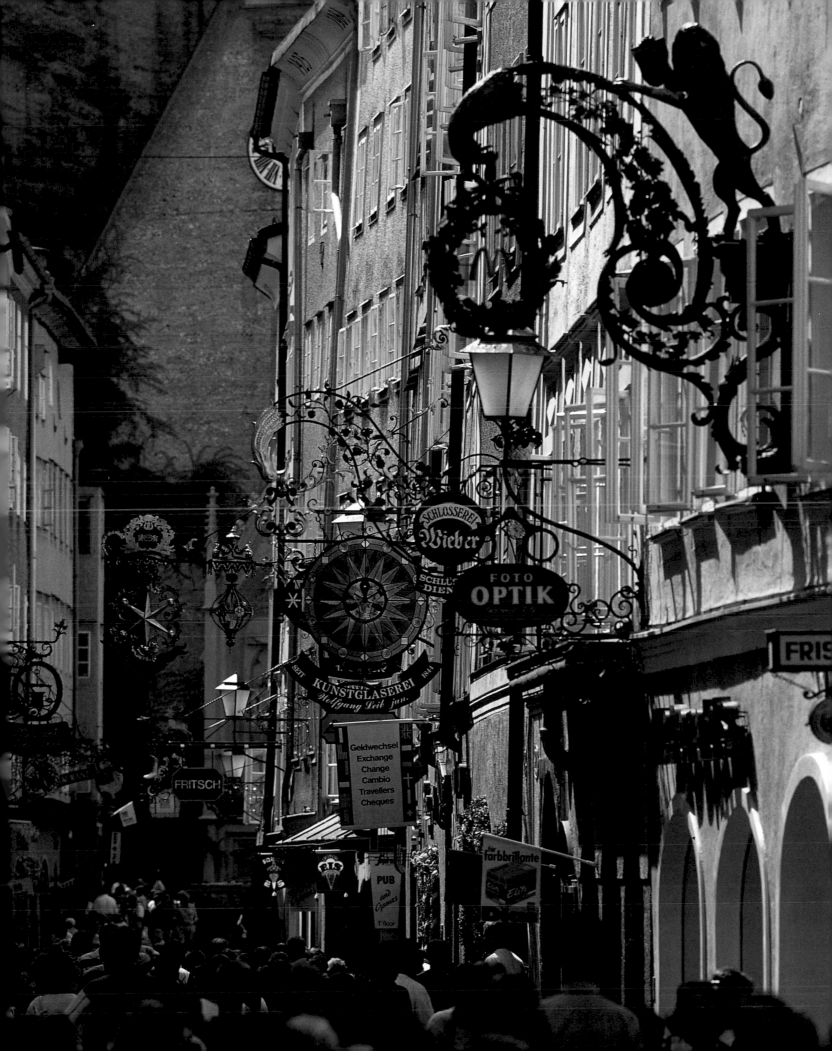

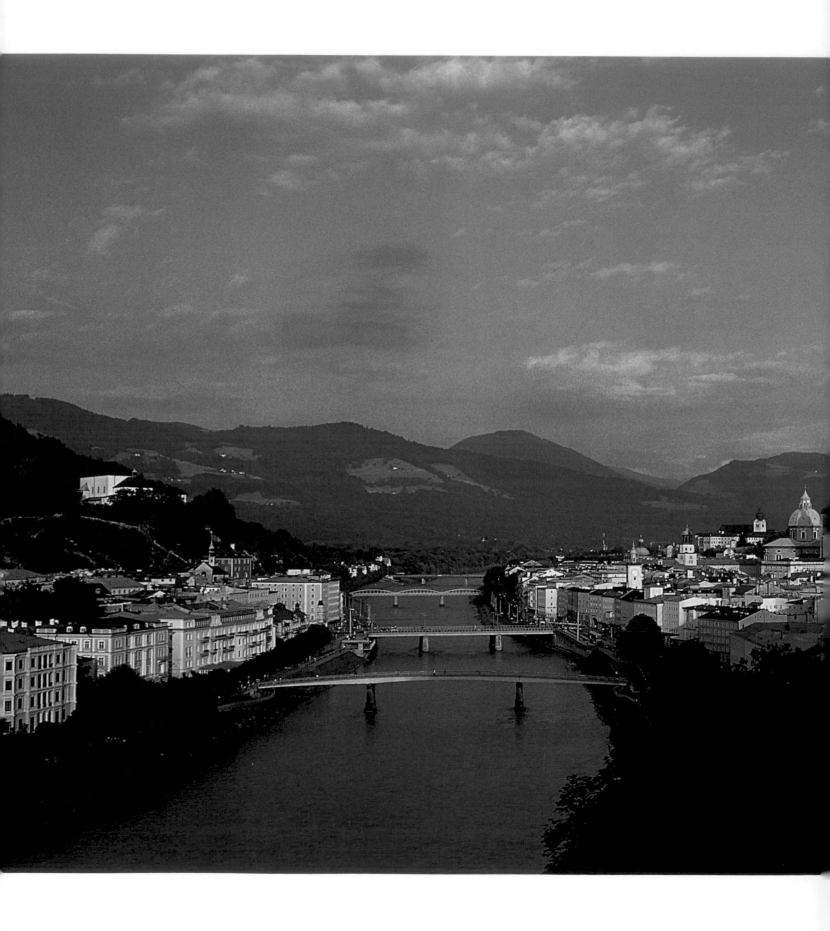

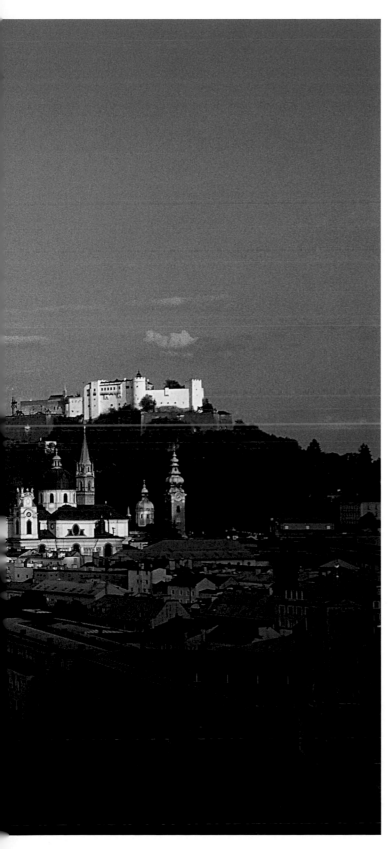

Left:
From Humboldt Terrace on Salzburg's Mönchsberg there's a magnificent view of the old town and Hohensalzburg Fortress.

Below:
Archbishop Wolf Dietrich von Raitenau had Schloss Mirabell built for his mistress.

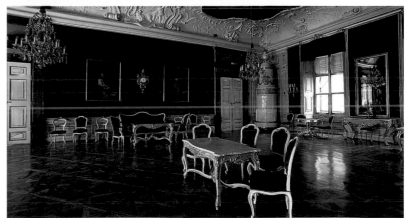

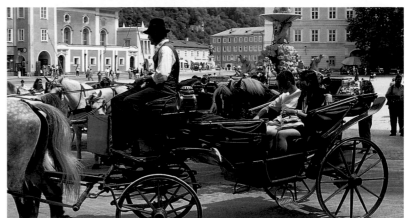

The exuberant conference room in the archbishop's palace in Salzburg (above centre) is still used for official state receptions. Horse-drawn carriages tout for custom on Residenzplatz (above).

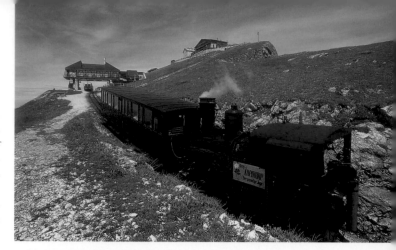

Right and below:
Well below the Sausteigalm on Zwölferhorn Mountain (4,994 ft/1,522 m) St Gilgen hugs the north shores of Lake Wolfgang (below). Its picturesque setting has made the lake the most popular in the Salzkammergut. The view from Schafberg Mountain on the opposite side of the water is no less spectacular. A rack railway runs up from St Wolfgang to the station at the summit (right).

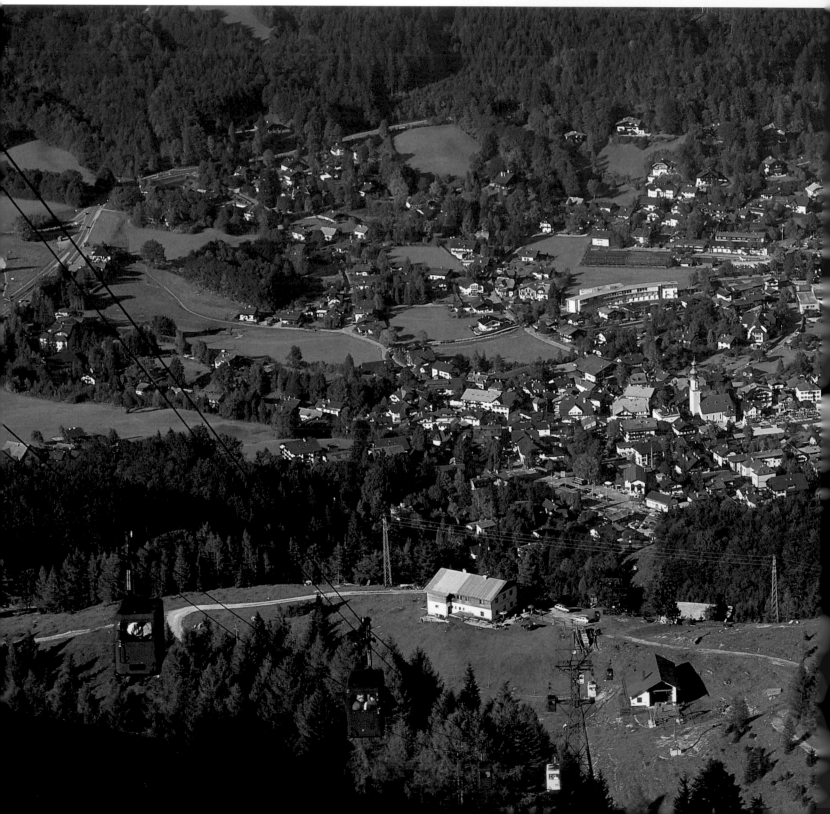

Left:
Near St Gilgen's town hall a plaque marks the place where Wolfgang Amadeus Mozart's mother, Anna Maria Pertl, was born. One of the rooms is now a mini-Mozart museum.

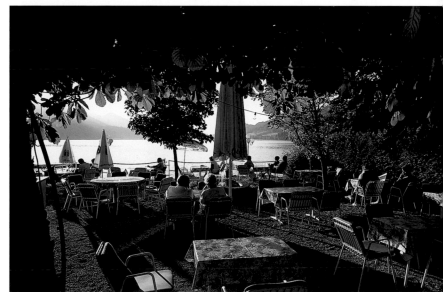

Schloss Fuschl on the lake of the same name (top) was erected as a hunting lodge for Salzburg's prince-bishops and in the 1950s was also used as a set for the »Sissi« films. It's now a luxury hotel which has accommodated such revered guests as Prince Rainier of Monaco, Richard Nixon and Billy Wilder. The shady beer garden on the shores of Lake Fuschl (above) may not be as elegant, but it's certainly a very pleasant place for a drink or two.

With its snow-capped giants, the Hohe Tauern form a mighty barrier between the valleys cutting off from the Salzach in the north and the tributaries of the Drava in the south. The striking world of mountains and glaciers has long been the eldorado of naturalists and Alpine fanatics. Over 150 summits in this area top the 9,800-foot mark (3,000 metres). Yet even long before the Felbertauerntunnel and the Großglockner-Hochalpenstraße were built, there was a flourishing trade in wine and salt here which was transported across the few passable routes through the mountains on the backs of horses who had to negotiate narrow mule tracks.

The old word for these precipitous passes was »Tauern«, which later gave the entire mountain range its name.

Large sections of the national park are permanently covered in snow and ice. There are no less than 254 glaciers, both large and small, the latter known locally as Kees. Although over the last century it has been observed that the ice is slowly melting, the snow fields of the Obersulzbachkees at the Großvenediger (12,054 ft/3,674 m) and the Pasterzenkees beneath the Großglockner (12,460 ft/3,798 m) are still of impressive proportions. On the high-lying terraces of the numerous valleys, glittering mountain lakes are filled by meltwater. The steepness of the rock faces and the depth of the valley floors here make the Tauern the area with the largest number of waterfalls in the Alps. The three falls at Krimml are one of the most spectacular natural phenomena in Europe with an overall drop of 1,247 feet (380 m).

Setting up a nature reserve in an area used intensively by man for centuries naturally was not without problems. Numerous

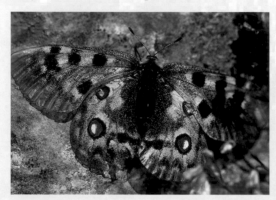

compromises had to be made, many of them extremely controversial. Much of the area is under private ownership and subject to ancient hunting, forestry and grazing rights. In the long term, attempts are being made to reduce damage to the mountain forests by red deer by reducing their number and secondly, a hunting ban valid throughout the year is to be imposed for endangered species such as the grouse (Tetraonidae), blue hare and marmot. The first steps in this direction have been made in the Salzburg part of the park, in the cirque above the Großglockner-Hochalpenstraße, where a trial ban on the hunting of chamois goats has been in effect since 1991.

Great endeavours are being made to try and reinstate species which have been driven out by man over the past hundred years. Ibex again populate the Freiwandspitze near the Großglockner, for example, and in the summer months the mighty griffon vulture (Gyps fulvus) soars over the peaks of the Tauern. It sleeps in the inaccessible, southerly-facing rocks of the Hollersbachtal. A hundred years ago, bearded vultures (Gypaetos barbatus) were also inhabitants of the region. Conservationists have been trying to reintroduce these huge birds back into the wild at the Krumltal near Rauris since 1986.

The care and preservation of the treasured mountain forests is a particularly im-

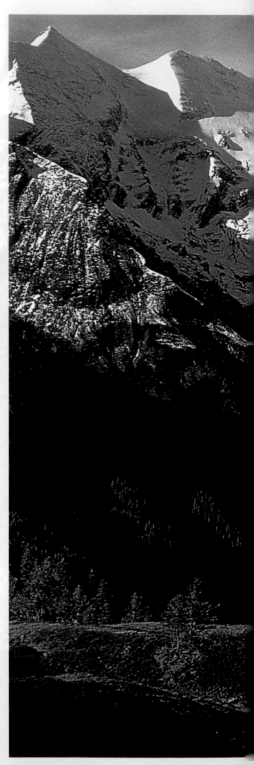

Far left:
It's not yet clear whether the ibex, to whom a monument has been placed at the Krimml Falls, will again settle here long-term.

Left:
The beautiful Apollo butterfly (Parnassiu apollo) lays its eggs sunny cracks in the

portant job. In Obersulzbachtal, for example, ancient larches above the Berndl-Alm protect the valley from erosion; the inner Defreggental has the largest forest area of Swiss or stone pine (Pinus cembra) in the eastern Alps.

The Alpine pastures and high-lying valleys of the Hohe Tauern provide refuge for rare varieties of wild flower and orchids. The paths are lined with purple mountain saxifrage (Saxifraga oppositifolia) and wild orchids (Orchis latifolia). Apollo (Parnassius Apollo) flit between edelweiss and rhododendrons in the brilliant mountain sun.

The entire national park is divided up into three zones. In the central zones, most of which encompass the high Alpine rocks and glaciers, any intervention in the natural world is strictly prohibited, with the exception of special hunting and fishing rights and limited use of the forests and pastures. In the countryside worked by the mountain farmers in the outer zones, the construction of new cable cars, chair lifts, ski pistes and hydroelectric power stations is not permitted. Only in the zones under »special protection«, currently a mere 4% of the total area, is use totally restricted, allowing nature to run its course without the interference of man.

Above right:
The now rare edelweiss (Leontopodium alpinum), popular booty for Alpine trophy hunters, is struggling to survive.

Right:
Where the Alpine rose (Rhododendron hirsutum) blooms, the shy and extremely agile chamois goat is not far away.

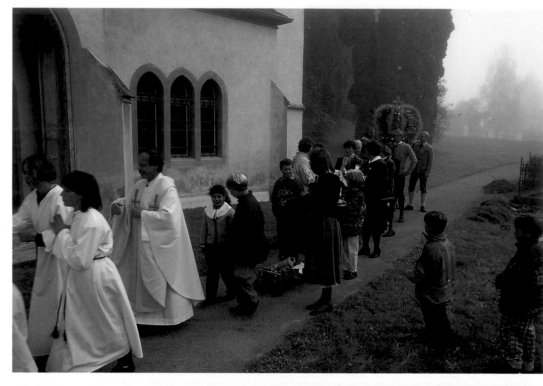

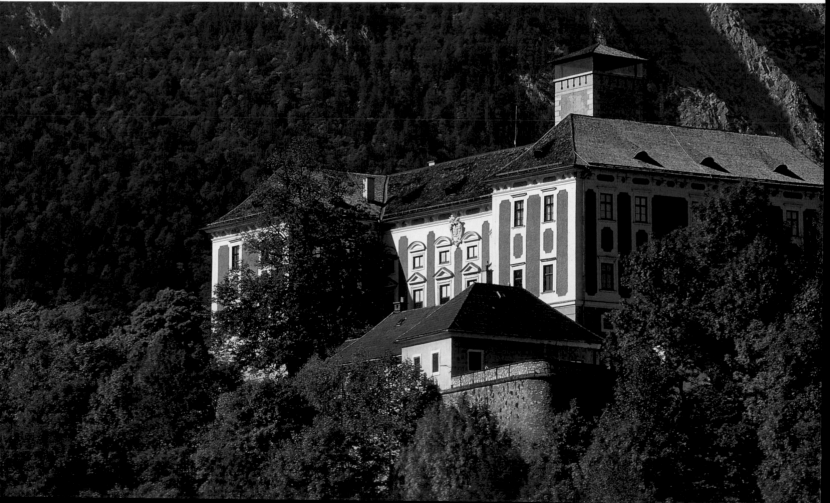

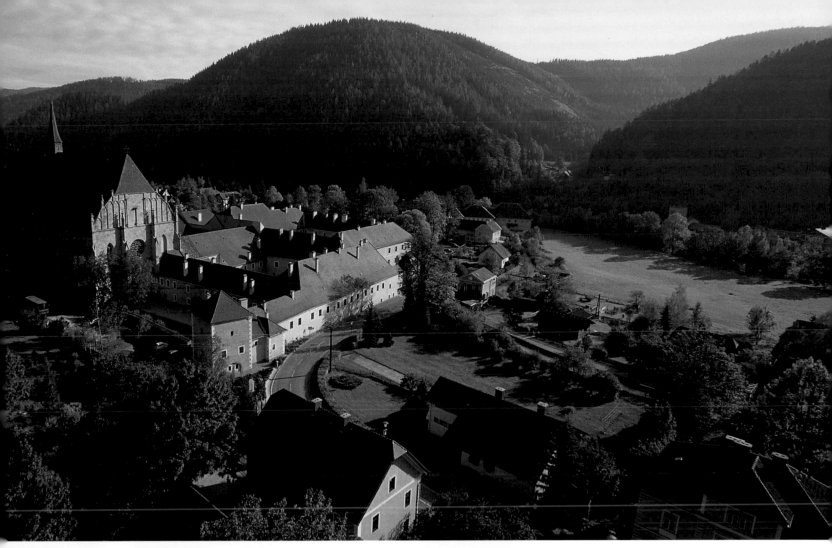

Top and bottom left:
*The childhood memories
of Styrian folk writer
Peter Rosegger
(1843–1918), published
in 1902, have the
nostalgic title »When I
was the Peasant Boy
from the Forest«. He
spent his youth in the
valley of the River Mürz
at the Kluppeneggerhof
in Alpl. The world of the
smallholder in the 19th
century is documented
in the museum at his
place of birth.*

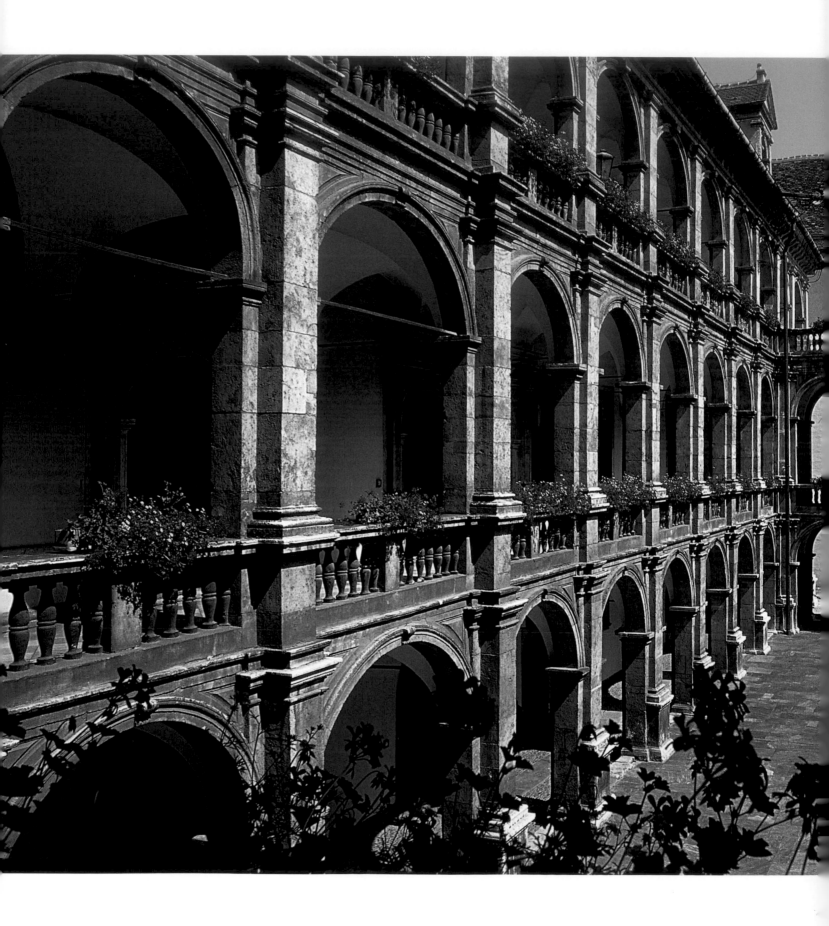

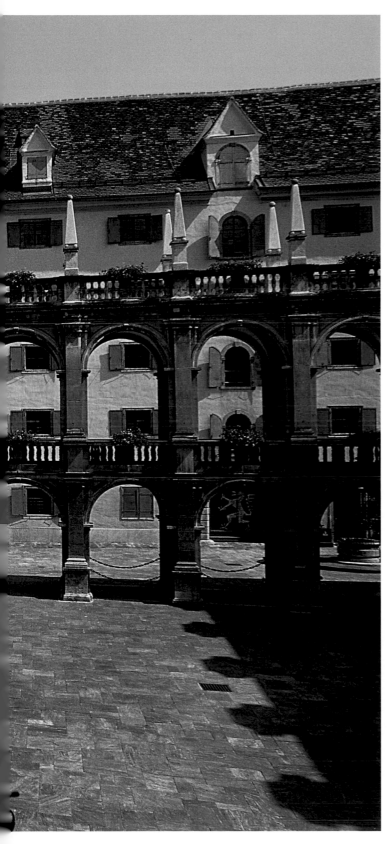

Left:
The Renaissance arcades of the Landhaus in Graz were constructed from 1557 to 1565 to provide an opulent setting for events staged by the Styrian body of representatives.

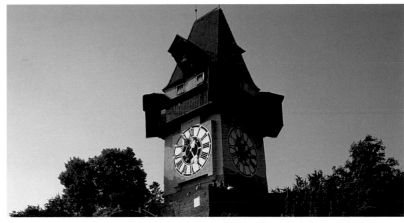

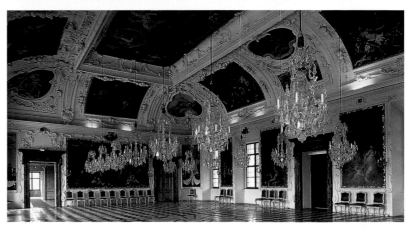

Top:
Visible for miles, the clock tower on Schlossberg (92 ft/28 m high) is Graz's city landmark.

Centre:
Numerous restaurants and street cafés entice you to wander around the old part of Graz.

Bottom:
In summer, grand concerts are held in the baroque ballroom of Schloss Eggenberg, ca. 2 miles/3 km west of Graz.

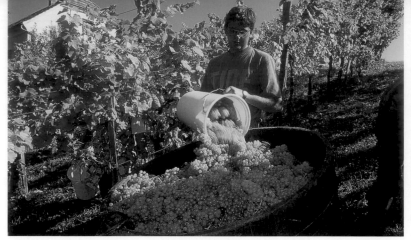

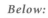
Below:
Many a good vintage grows in the steep vineyards climbing up to the Augustinian monastery of Stainz on the Schilcher Weinstraße.

Right:
Looks like a good year for wine in southern Styria! A rich harvest is the well-earned reward for months of hard toil in the vineyards.

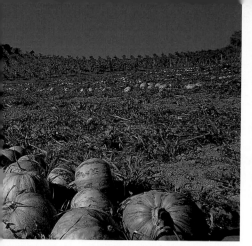

Left:
Wine isn't the only thing that grows well in the mild climate of southern Styria. Local farmers can also count on good yields from their pumpkin fields and orchards.

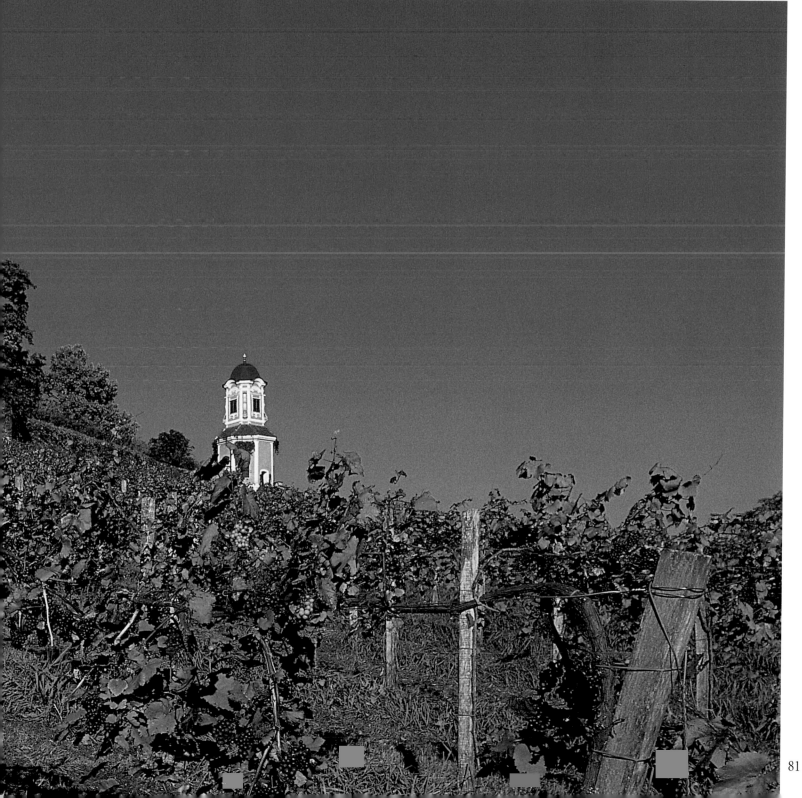

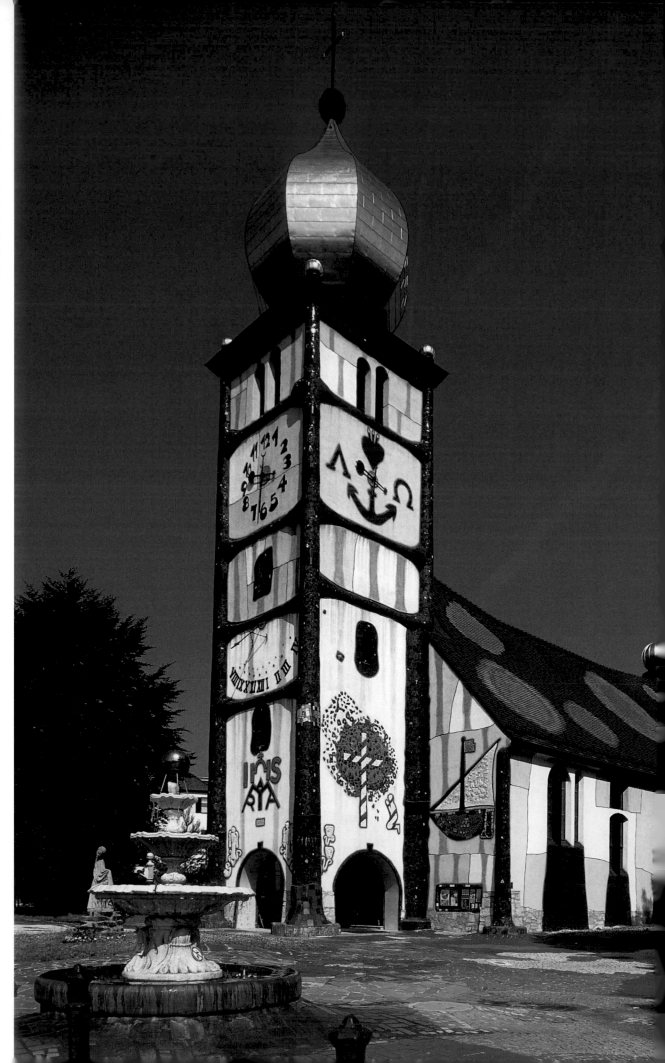

Bärnbach in Styria's brown coalmining area west of Graz has a surprise in store. Artist Friedensreich Hundertwasser has given the baroque parish church of St Barbara's a completely new look. Its bright colours, mosaics and sparkling golden dome now shine out across the countryside.

On a hill above
Mariazell in Styria
stands the baroque
basilica of Austria's
largest and most
frequented pilgrimage
church. Legend has it
that the church was
established as a result of
the work of St Lambrecht.

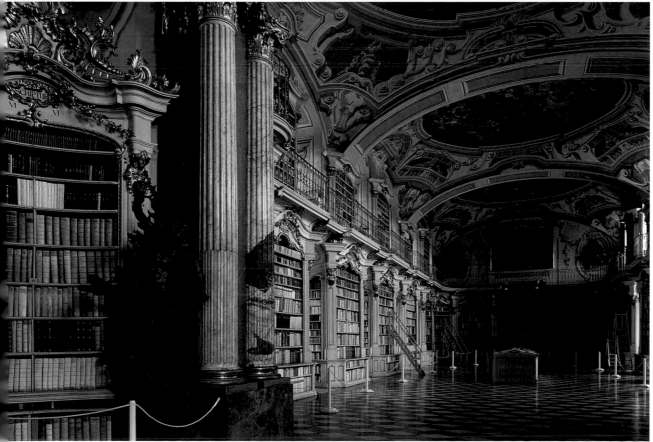

The baroque monastery
library with its 145,000
volumes is the showpiece
of the Benedictine abbey
of Admont in Styria. The
sumptuous chamber of
books, spread over two
storeys, is 236 ft (72 m)
long.

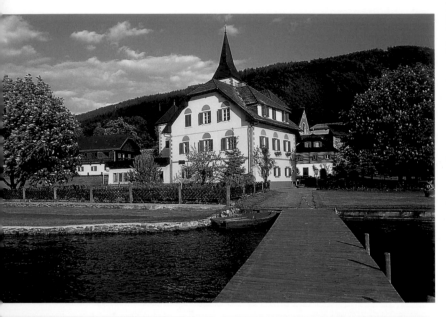

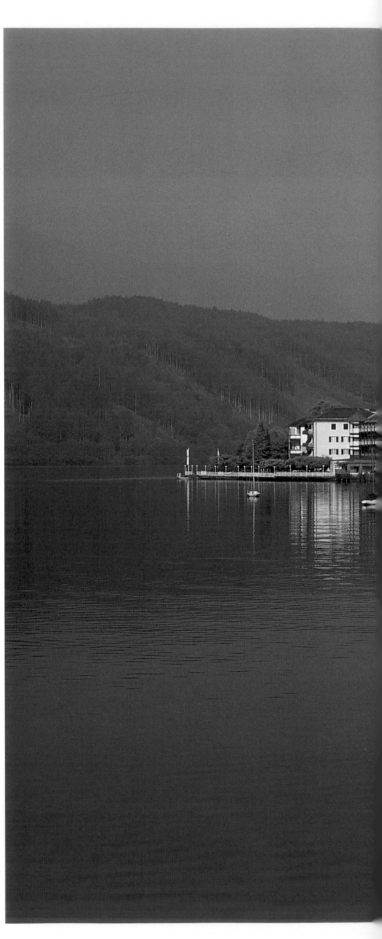

Below:
The Benedictine
monastery of Ossiach
on Lake Ossiach in
Carinthia provides a
charming backdrop to
the music festival
which takes place here
each summer.

Above:
The Benedictine
monastery in Millstatt
was founded in 1070 to
accommodate the Order
of Knights. In the
16th century St George
turned the monastery
into a splendid
Renaissance complex.

Right:
Tourist brochures refer
to Millstatt as the »Nice
of Carinthia«. Early
settlers along the
northern shores of Lake
Millstatt were the
Romans. Later influ-
ences are evident in the
villas lining the lake-
side, modelled on the
Viennese architecture of
the late 19th/early 20th
centuries.

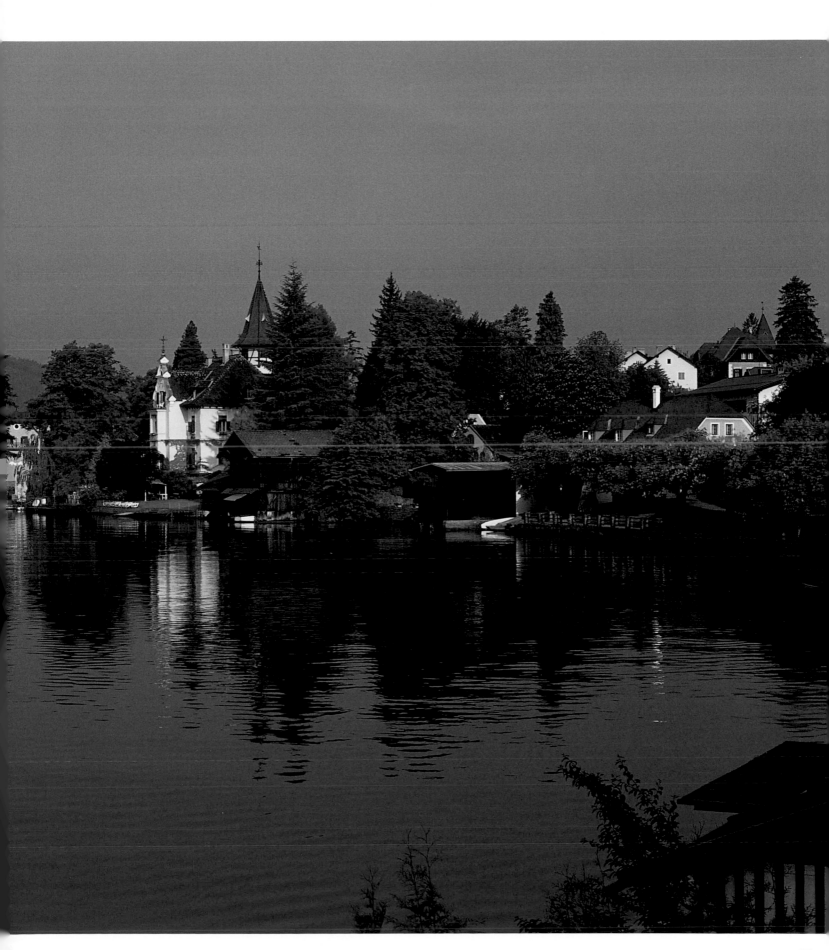

Right:
The main square with its statue of the Trinity forms the nucleus of

Villach. The traditional town on the River Drava is known as the »secret capital« of Carinthia.

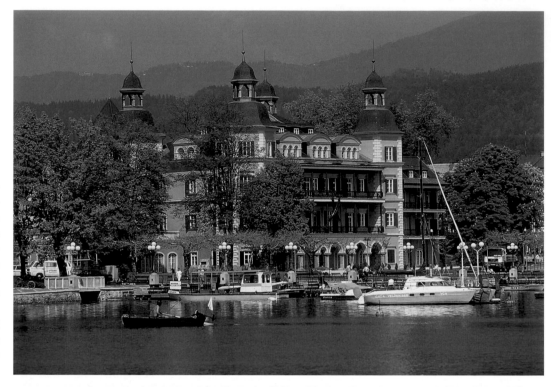

Right and below:
Probably the best known of Carinthia's 200 lakes is Lake Wörther with its local landmark, the parish church of Maria Wörth (below). Velden on the western shore is the largest holiday resort. The famous Schlosshotel (right) dwarfs the moorings along the lakeside promenade.

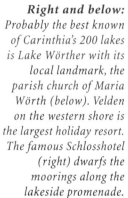

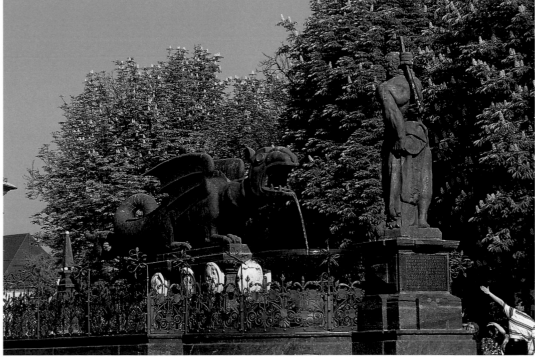

Left:
The Carinthian capital of Klagenfurt has a lindworm on its coat of arms. A fountain depicting the mythical beast can be found on Neuer Platz.

Page 88/89:
The mood is almost Tuscan when the morning sun shines through the autumn mists rising up out of the valleys near Villach.

CASTLES, WINE AND WALTZES

In 1744 Empress Maria Theresia commissioned a stately palace to be erected on the site of a hunting lodge. With a façade over 650 ft (200 m) long and 1,441 lavishly furnished rooms, Schloss Schönbrunn near Vienna is said to trump Versailles in opulence and size.

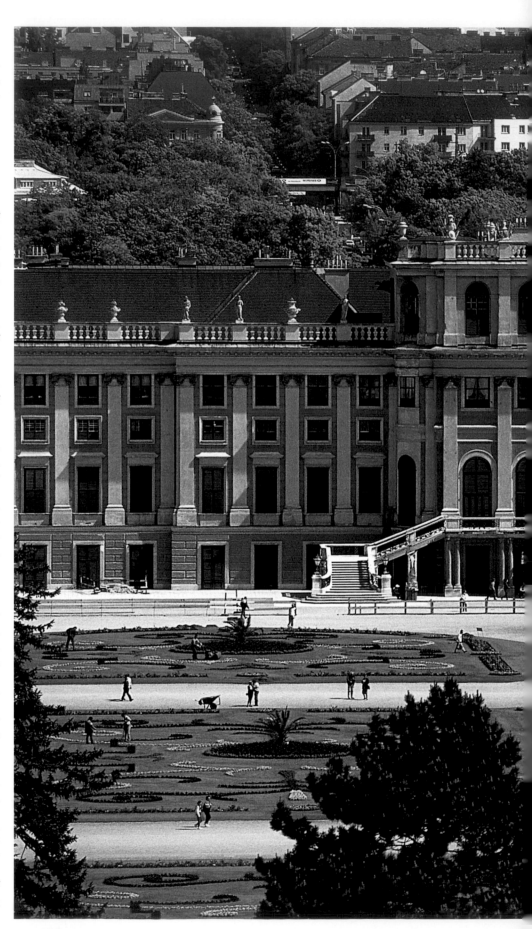

The mild climate at the edge of the Pannonian plateau and the vines which flourish from the Wachau to the south of the Burgenland lend the northeast of the Alpine republic around the capital of Vienna its special charm.

The »beautiful blue Danube« divides Lower Austria with its provincial capital of St. Pölten into two almost equal halves. Skirted by castle ruins and steep vineyards, the river lazily winds its way through the Wachau between the baroque monasteries of Melk and Göttweig.

Towards the Czech border, large stretches of coniferous forest, moor and heathland cloak the tranquil Waldviertel. The scenery of the Weinviertel is gentler with its vineyards, fertile loess soil and distinctive, narrow streets of wine cellars in which many a good vintage slowly matures. The Mostviertel south of the Danube is characterised by its fruit plantations and cattle farming.

The ancient metropolis of the multiracial state has sacrificed nothing of its former glory and bubbly vitality. Its aura as the »world capital of music« is undisturbed. Imperial Vienna, much as it was under the kaiser around the cathedral of St. Stephen, at the old Hofburg, in the pompous, late 19th-century edifices along Ringstraße and Schloss Schönbrunn, casts its spell over all who behold it. The Prater funfair, the wine tavern and legendary coffee house hold almost mythical qualities.

To the southeast of the Danube capital sprawl the plateaux of the Marchfeld with their wild river islands and the Burgenland. The wide bank of reeds encircling Europe's only steppe lake, Lake Neusiedler, is a unique ornithological paradise and protected nature reserve which transcends the national boundary. The Seewinkel on the eastern shores of the lake smacks of Hungary with its unspoilt puszta scenery.

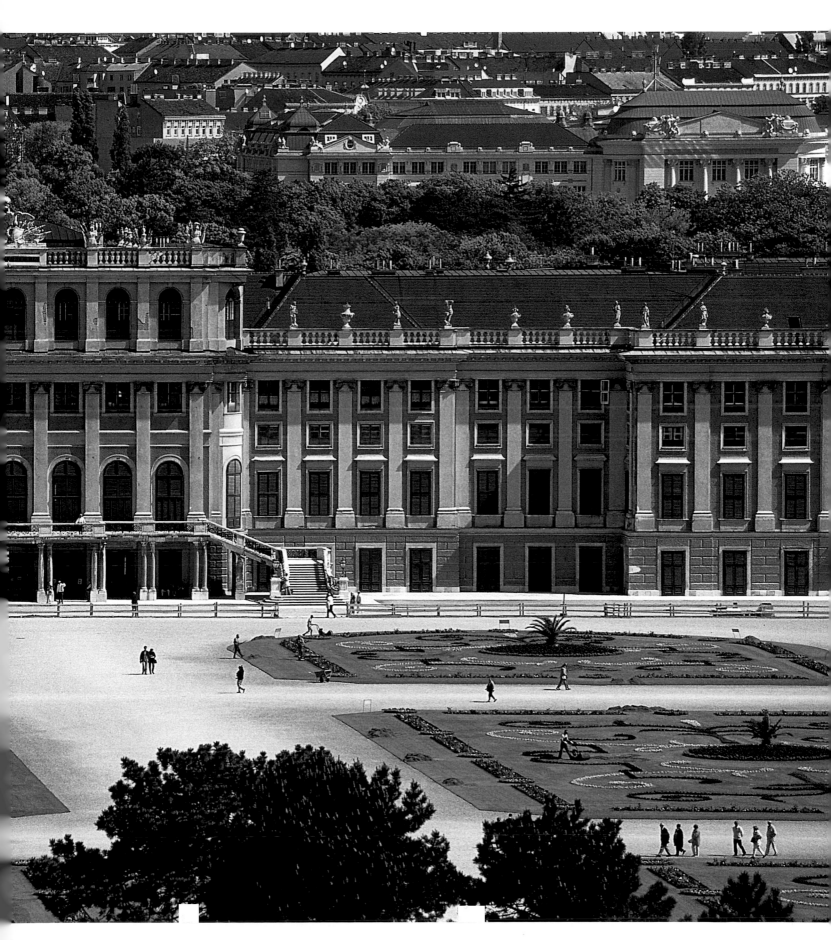

ROM VIENNA TO THE BURGENLAND

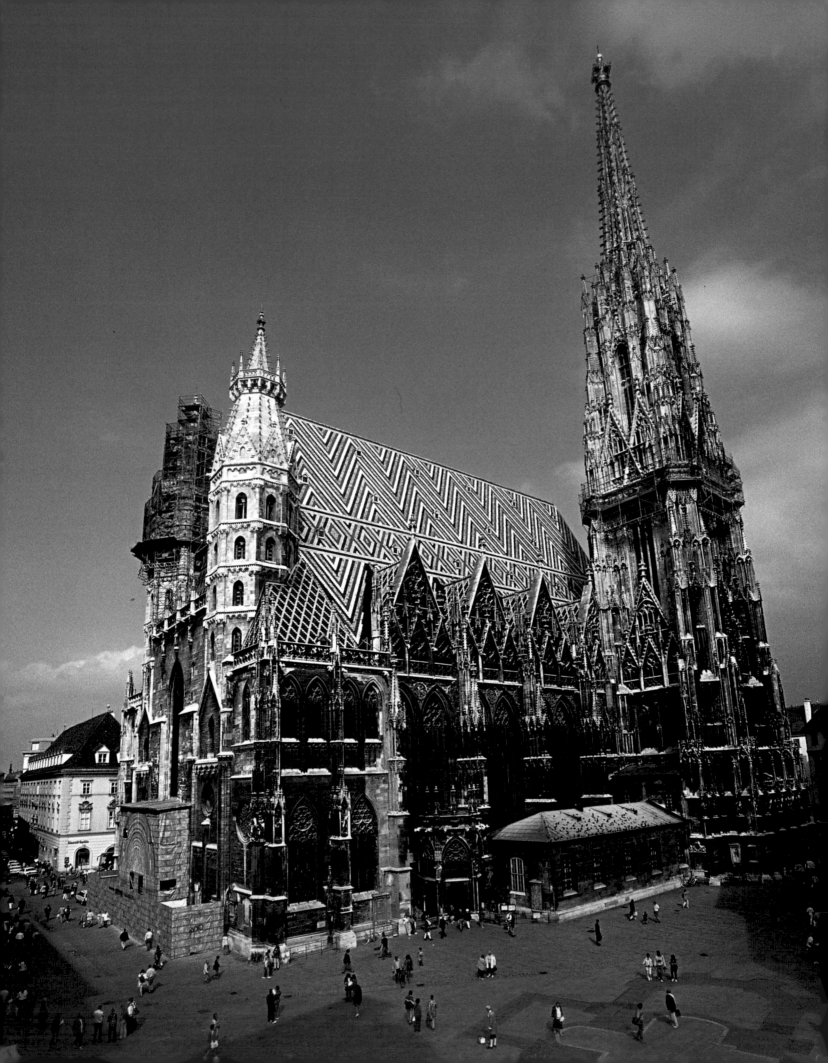

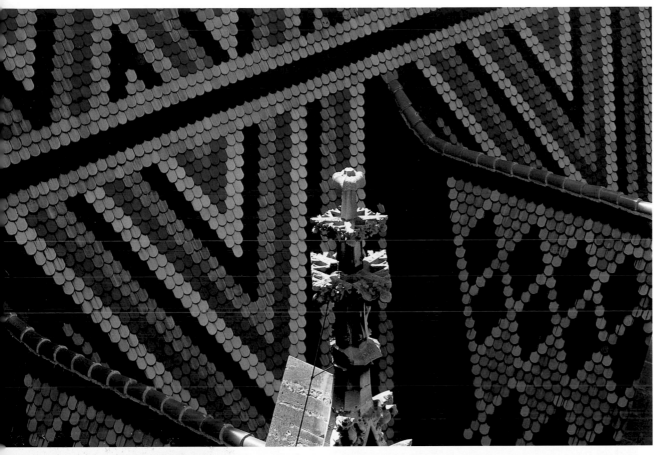

Page 92:
St Stephen's Cathedral has survived into the new millennium from the days of the dukes of Babenberg as the true symbol of the city of Vienna. Construction of the Gothic edifice was begun in 1304 under Duke Albrecht II and only completed in 1450. Whereas the north tower remained unfinished, the south tower of »Steffl« can claim to be the third-highest steeple in the world at 446 ft (136 m).

Left:
343 steps climb up to the chamber at the top of St Stephen's, high up above the colourful tiles of the late Gothic sloped roof. Unforgettable views out across the city roofs compensate for the strenuous ascent!

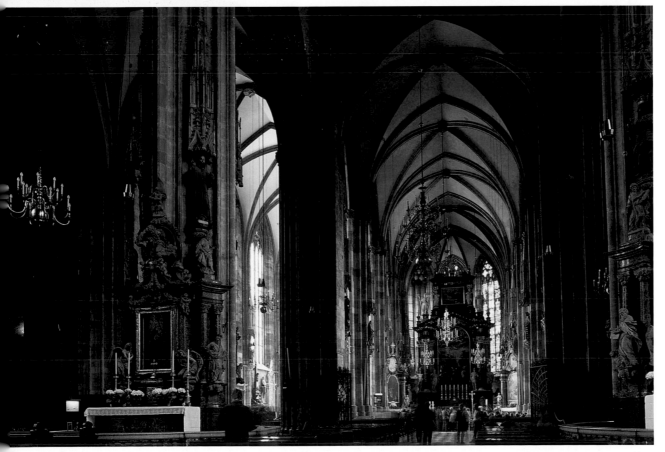

Left:
Life-size statues of saints flank the tall compound piers which bear the weight of the net and star rib vaulting in the aisled nave of St Stephen's Cathedral. The catacombs under the church can only be visited with a guide.

Below:
Kids big and small can enjoy themselves on the merry-go-rounds, roller coasters and bumper cars at Vienna's Prater. The star attraction, number one with visitors since the fair's opening in 1897, is the Big Wheel.

Bottom:
Johann Lukas von Hildebrand began building the two Belvedere palaces for Prince Eugene in 1700. Oberes Belvedere witnessed the signing of the Austrian Treaty of Independence on 15 May 1955.

Right:
The street cafés clustered around the Pestsäule in Salzburg marble along the Graben in Vienna are inviting. Why not stop off for a »Melange« or »Großer Brauner«?

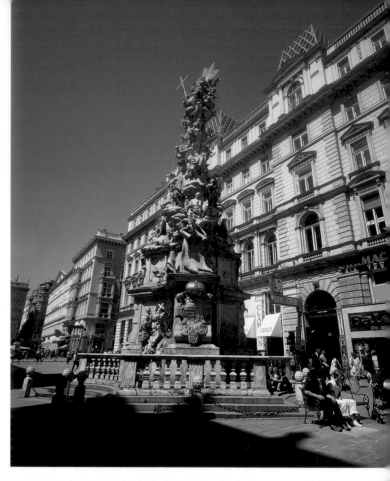

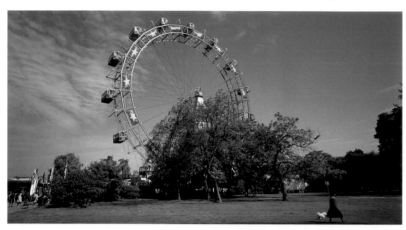

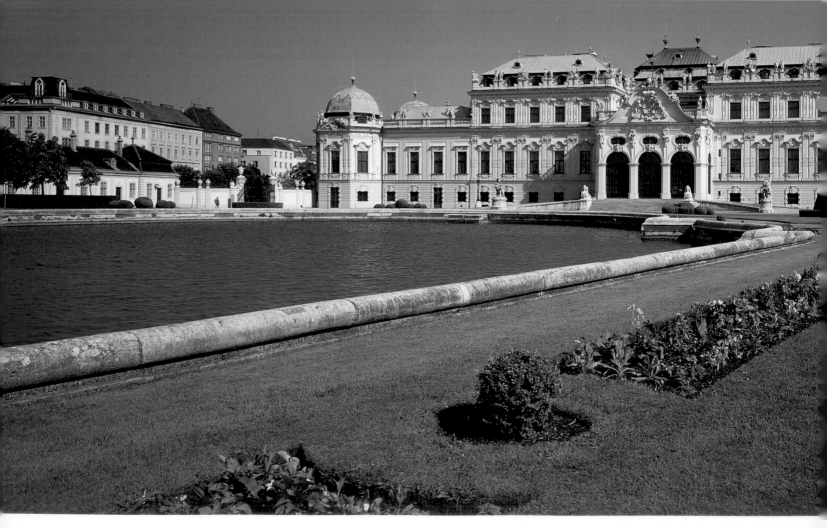

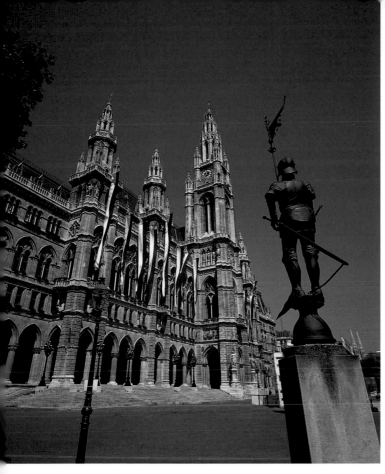

Left:
The monumental neo-gothic town hall with its seven courtyards and a tower over 320 ft (98 m) high was built from 1872–1883 on Ringstraße. Concerts take place in the arcaded quadrangle as part of the Vienna summer music festival.

Below:
The spacious Hofburg was the home of the Habsburg dynasty for over 6 centuries. A mighty cupola crowns what was the imperial chancellery, finished in 1893.

Below centre:
On Heldenplatz in front of Vienna's Hofburg, horse-drawn carriages await new customers wanting to take the classic tour past the splendid buildings on Ringstraße.

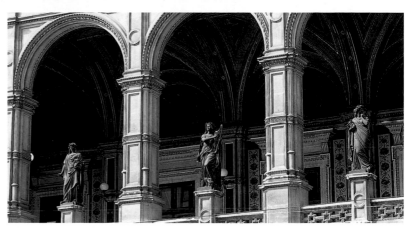

Above:
The façade of the Vienna State Opera (1861–1869) on Opernring is deceptive; what appears to be early French Renaissance is in fact Historicism.

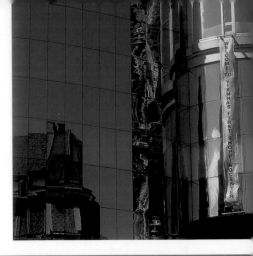

Below and right:
Architect Hans Hollein's designs for the new Haas & Sons textiles building on Stock-im-Eisen-Platz in Vienna (below) were the subject of controversy right from the start. The enormous, curved glass front mirrors the Gothic shapes of St Stephen's Cathedral opposite. All agree, however, that the view of the cathedral from the café at the top of the Haas Haus (top right page) is the best in town.

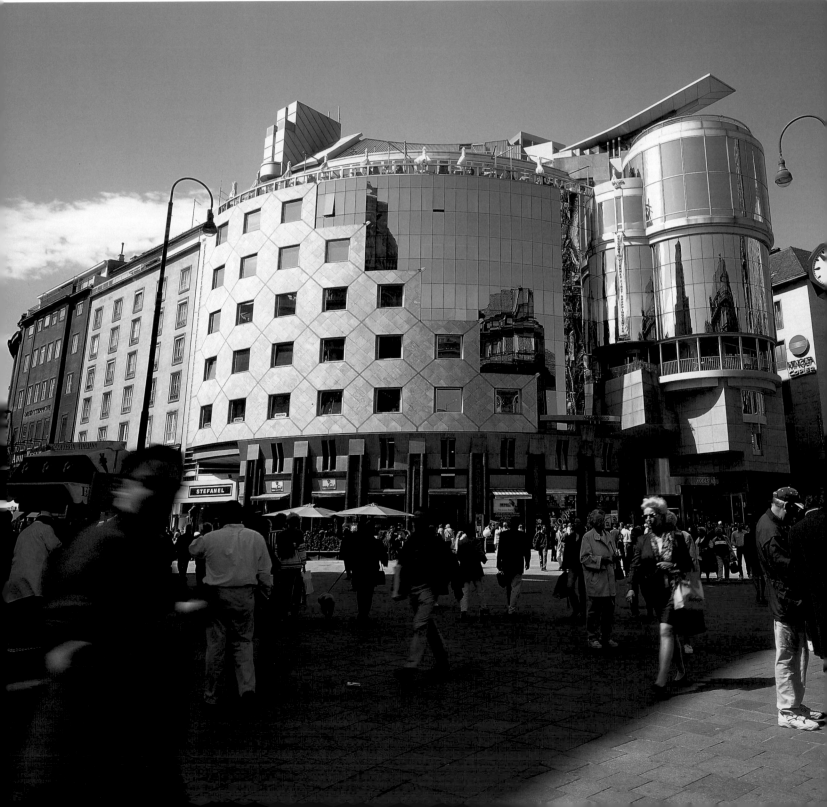

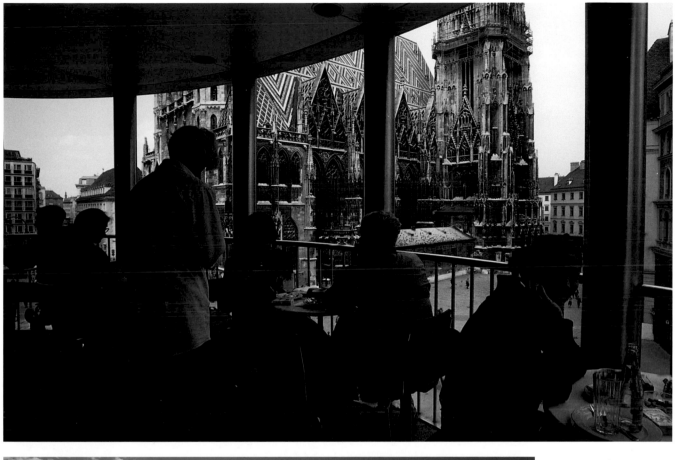

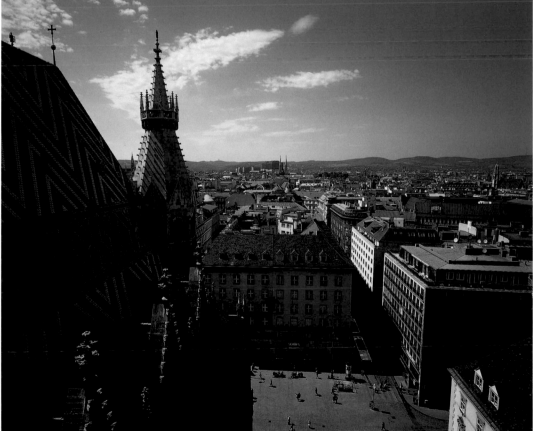

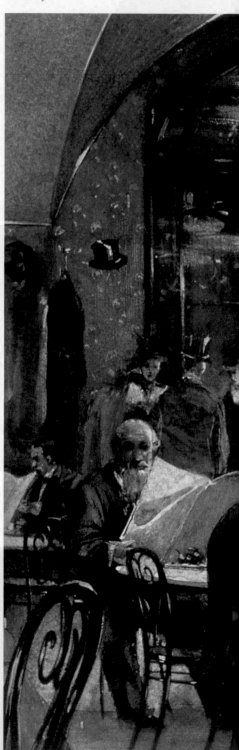

P ondering over a cup of coffee is a pleasant pastime – and you certainly don't have to be in Austria to enjoy it. Yet it helps. In and around Vienna, coffee is more than just a hot beverage; it has become part of the national consciousness. This is even indicated in the way the word is spelt and pronounced. With the stress on the first syllable, café is just a drink; with the emphasis on the second, Kaffee is a philosophy. Used in conjunction with the definite article (der Kaffee), it is a way of life. And the Viennese coffee house is more than just a pub; it's a weltanschauung all of its own.

»The Viennese coffee house is not just unique in its kind«, wrote Austrian author Karl Johann von Braunthal in 1840, »it is also extremely difficult to imitate, like the Hungarian hussars. Yes, there are also English and Prussian hussars, just as there are French, Italian and German cafés; there are, however, neither genuine hussars nor genuine coffee houses, for Hungarians are born hussars and the Viennese coffee house people.« Funnily enough, the coffee is actually the least important ingredient in a real coffee house. One can comfortably say that only around ten in a hundred visitors to a coffee house actually go in for a fix of the bean. So why enter one of these establishments? »In the coffee house are the people who want to be alone but need company to do so« is the succinct reasoning offered by critic and journalist Alfred Polgar. The café was and still is the extended living room of the Viennese, whatever their age or social class. Where else but in the public seclusion of the coffee house can you find such an informal gathering of retired businessmen, students, artists and those who like to think they are, upper-class gossips, bankers and punks? The social and cultural life of the Danube metropolis blossoms again around

the marble tables. »Time flies by in the coffee house. People play cards and billiards, read the newspaper, smoke a cigarette; they chat, write letters and meet people who are so interesting that they could never invite them back to their homes.« When Otto Friedländer wrote these lines in 1948, he was referring to the decade-old tradition of cafés patronised by artists and literati. In Vienna at the turn of the 19th century, coffee houses were the meeting place, domicile and think tank of the Vienna bohemia, who spent much if not all of their lives at their favourite institution. Alfred Polgar's local, Café Central on Herrengasse, was »a way of looking at the world, one whose main prerogative is not to look at the world.« This is the place Karl Kraus and Sigmund Freud frequented, and where a Russian emigrant called Trotsky played chess for hours on end. When the foreign secretary of Austria was told that revolution had broken out in Russia, he is said to have smiled in disbelief and replied: »Get away with you, who is there to cause a revolution in Russia? Mr Trotsky from Café Central, perhaps?«

The Vienna scene still meets up at the coffee house. This is where you can have a natter, watch the world go by or hide behind one of the newspapers put out for the clientele. There is always a huge assortment of national and international rags to choose from. Those who ask »Is this paper free?« should expect the classic retort: »Is there any freedom of the press these days?«

COFFEE HOUSE

GUIDE TO COFFEE

NSPÄNNER: double mocha a glass with whipped eam	GROSSER/KLEINER BRAUNER: large/small cup of coffee with a little milk	KAPUZINER: black coffee with whipped cream
AKER: double mocha in a ass with rum	GROSSER/KLEINER SCHWARZER: large/small cup of mocha	KONSUL: watered-down mocha with whipped cream
ANZISKANER: milky coffee th cream and chocolate kes	KAISERMELANGE: milky coffee with an egg yolk	MELANGE: coffee with lots of milk, usually frothed
		PHARISÄER: coffee with rum under a blob of cream

Right:
According to the list of addresses for Vienna, from the turn of the 19th century Alfred Polgar lived at Café Central. Here he received his post and his literary colleagues.

When the waiter asks what he may bring you, you should never just order plain old coffee. Requests like these, according to a bon mot coined by Friedrich Torberg, are likely to cause as much disconcertment »as someone at the offices of the Cunard Line asking for a ship«. For although, or perhaps

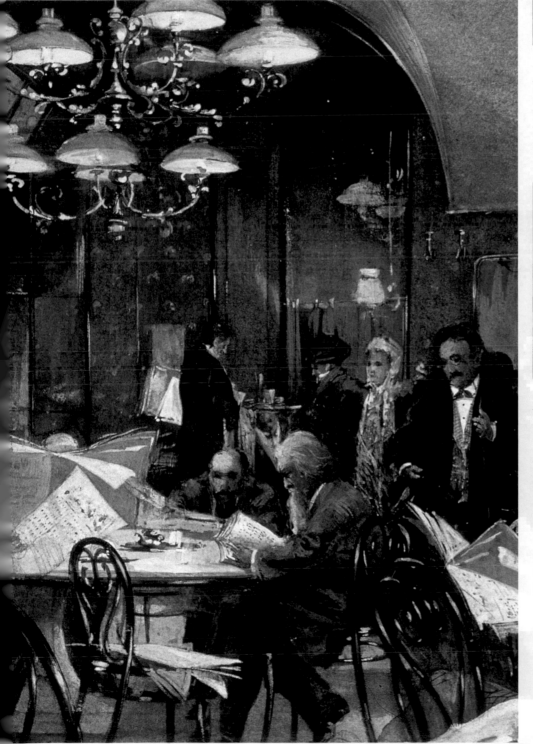

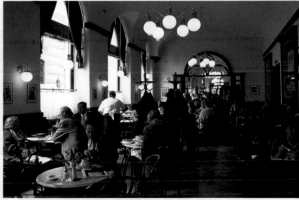

At Café Griensteidl writers Hermann Bahr, Hugo von Hofmannsthal *and Arthur Schnitzler engaged in fierce battles of words.*

because the drink plays a minor role in obtaining entrance to a coffee house, so to speak, the many different methods of preparing the aromatic brew are the star attraction. With a Kleiner Schwarzer, a Großer Brauner or an Einspänner in front of you, the discerning connoisseur is free to while away hours of leisure offered with such lavish abandon at the Viennese coffee house.

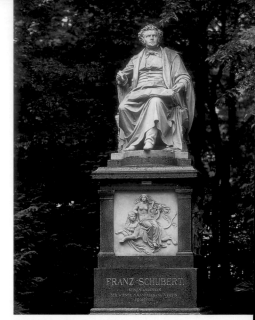

Right:
The memory of the great composers who helped make Vienna music capital of the world is very much alive. A marble statue in the Stadtpark depicts Franz Schubert (1797–1828).

Below:
Vienna's enormous Hofburg ends on Heldenplatz in the neo-Classical Neue Hofburg bordering on Ringstraße.

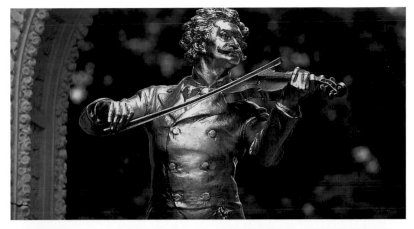

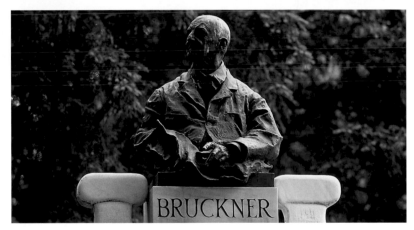

Top:
The Stadtpark also has an effigy in gold of the king of the waltz, Johann Strauß (top right). Vienna still sways in three-four time, whether at the traditional Opernball or to the less formal strains of a punk fiddler in the old town (top left).

Above and centre:
Three years after his death, Anton Bruckner (1824–1896) had a bronze bust installed in the Stadtpark in his honour (above). Johann Strauß and several other musicians of great repute, such as Gluck, Beethoven, Schubert and Brahms, were laid to rest in Vienna's main cemetery (above centre).

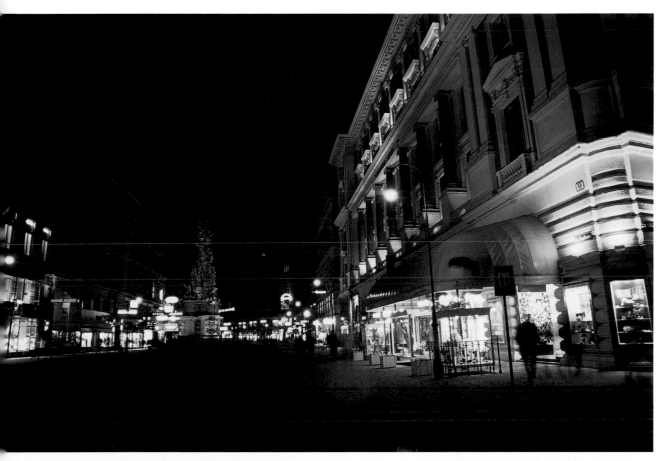

Page 102:
A stroll through the centre of Vienna wouldn't be complete without calling in at the Hotel Sacher café for a slice of that famous gateau.

The boundary of Vienna's old town ran along Graben in the 13th century. The wide avenue, once a raucous market place, is now an elegant boulevard of posh shops and street cafés at the heart of Vienna, busy until well into the evening.

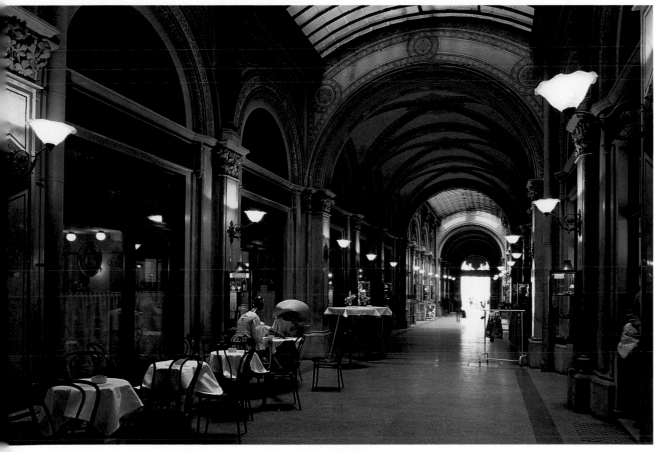

Vienna is consumer's paradise. Not far from Graben is the exclusive Freyung mall, where you can window-shop, browse and try on prospective purchases in style.

Right:
One of the most delightful areas of recreation near Vienna is the park which surrounds Laxenburg Castle. The small lake encircling the Franzensburg can be peacefully explored by rowing boat.

Below:
The Augustinian monastery of Klosterneuburg dates back to a complex founded by Margrave Leopold III in the 12th century.

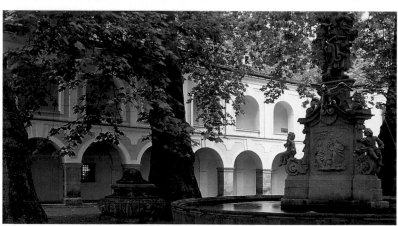

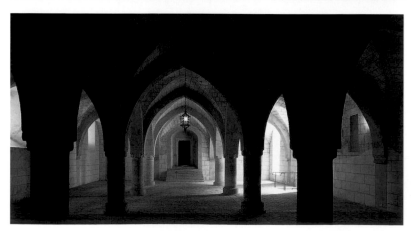

The Romanesque forms of Heiligenkreuz Monastery (above) effuse the Spartan spirit of the Cistercian order. The fountain in the monastery quad (above centre) is the work of Venetian sculptor Giovanni Giuliani who spent the end of his life here.

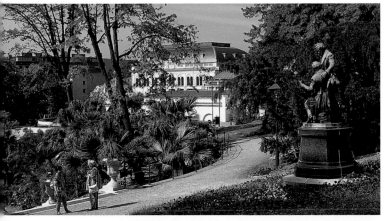

Left:
*The casino in the spa
gardens at Baden is as
popular an attraction as
the sulphur springs here.
The health resort has
been a favourite with
Viennese society since
the beginning of the
19th century.*

Below:
*Good new wine is not
only available in
Grinzing or Nußdorf;
there are also plenty of
taverns in Gumpoldskir-
chen offering sanctuary
from the hectic bustle
of the city – and serving
wine, of course.*

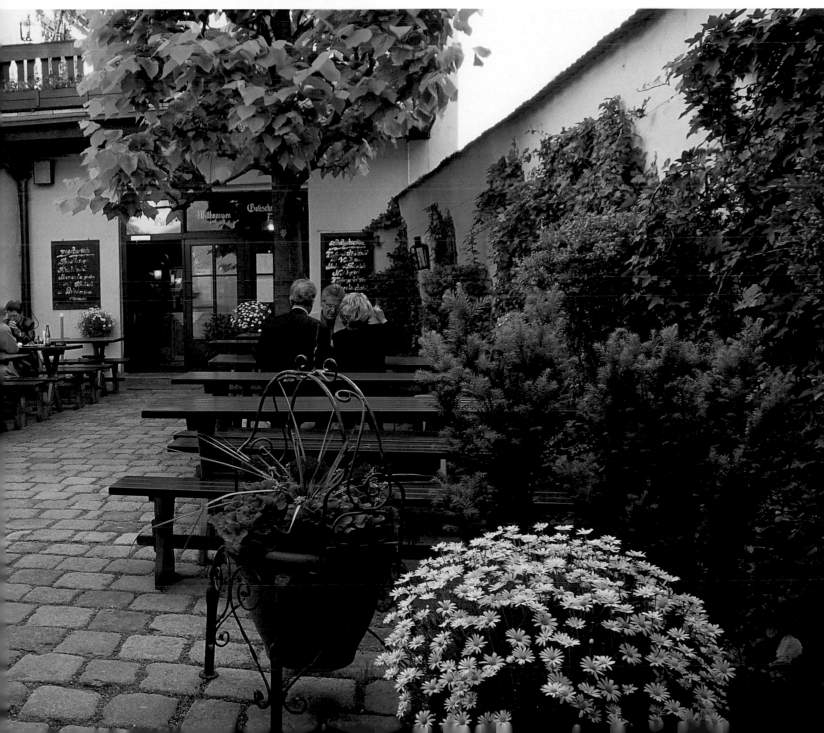

The cultivation of wine in the Wachau region goes back to the Romans. The Tausendeimerberg near Spitz is said to produce a thousand buckets of wine in good years.

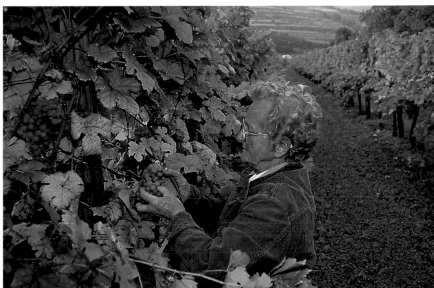

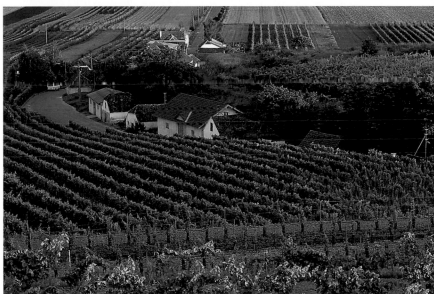

Left and above:
In the fertile valleys of the Weinviertel, vineyards alternate with fields of wheat and sugar beet (above). Jetzelsdorf with its long street of cellars (left) is typical of the villages here producing many a piquant vintage.

The Benedictine monastery of Melk, founded by Babenberg margraves in the 11th century, was redesigned in sumptuous baroque in the 18th century. The marble room (below) provided the ceremonial aura for grand receptions. The collegiate church (top right page) is an orgy of red and gold. The ceiling fresco in the nave (right) illustrates the celebration of St Benedict..

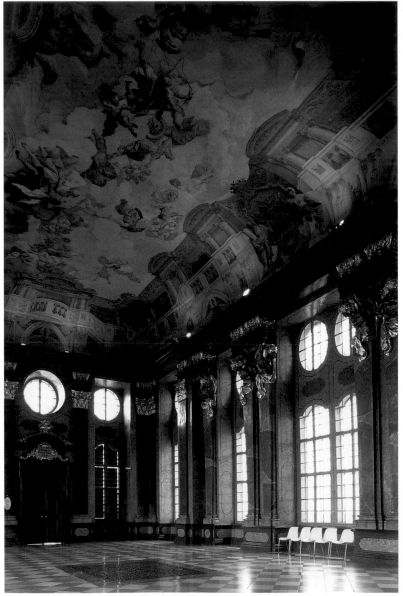

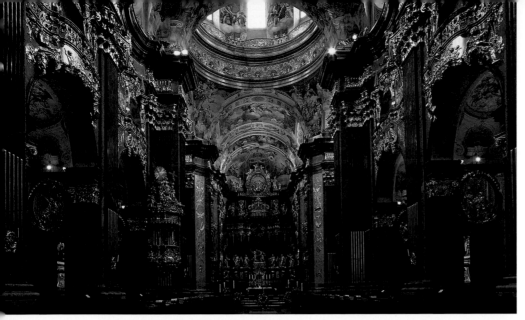

Page 110/111:
Krems on the Danube was granted its town charter in the 12th century, making it the oldest town in Lower Austria. At night the Piarist church illumi nates the narrow streets of the old town.

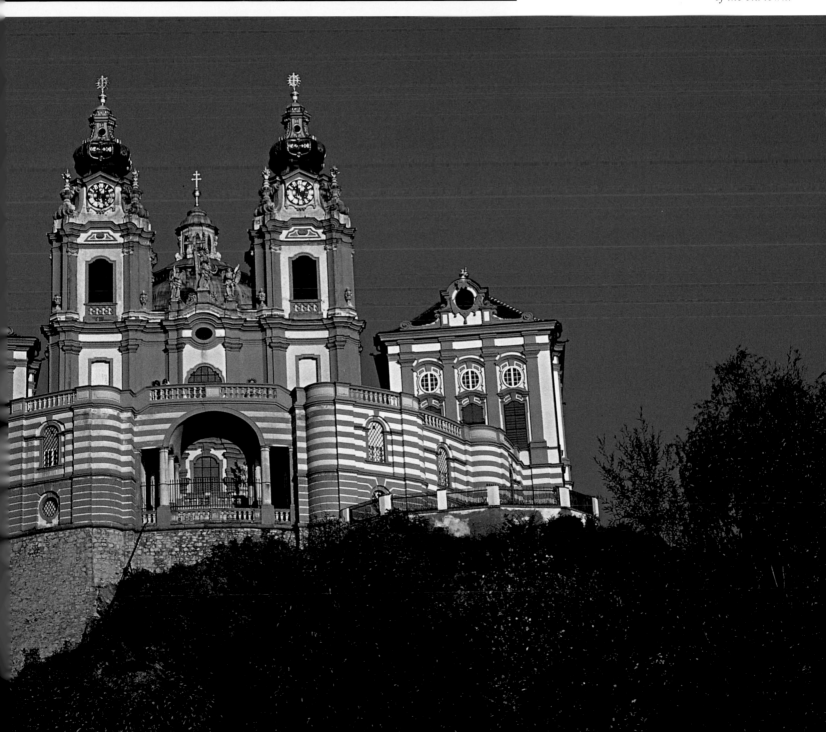

Top:
*Lower Austria is famous for its many castles.
At Kornneuburg, where the Viennese Forest edges
towards the banks of the River Danube, Burg
Kreuzenstein rises tall above the valley. The fortress
was captured and destroyed by the Swedes in 1645
and rebuilt in neo-Gothic in 1879 as a Romantic
vision of the past.*

Bottom:
*Moated Renaissance Grafenegg Castle was refur-
bished between 1840 and 1873 by Vienna's cathe[...]
architect Ludwig Ernst. Atmospheric concerts are
performed here each year from May to October.*

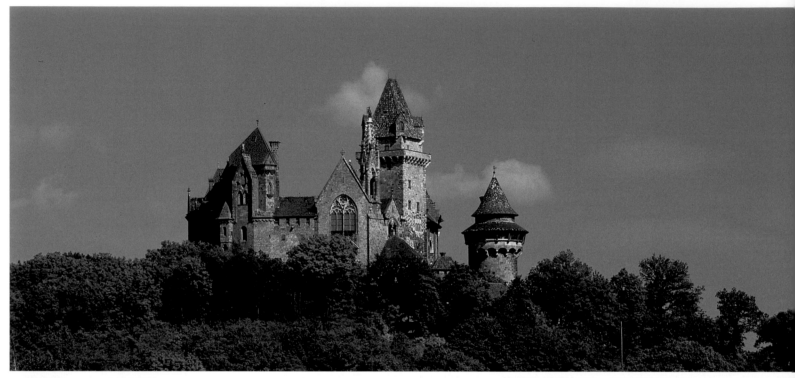

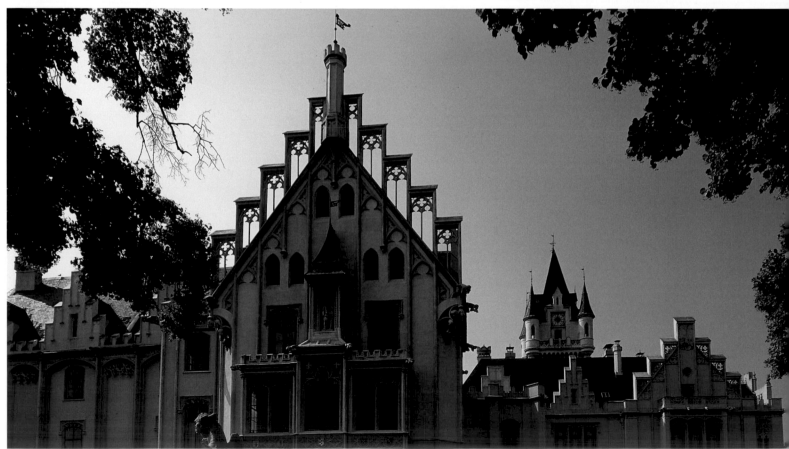

Top:
Burg Ottenstein looms defensively out of the trees above Kamp Valley in the Lower Austrian Wald-viertel. The mighty keep is from the 12th century, when the site was fortified by Hugo von Ottenstein.

Bottom:
St Pölten has been the provincial capital of Lower Austria since 1986. Beneath the decorative column on the marketplace at the heart of the old town, stallholders sell fruit and vegetables from the sur-rounding area.

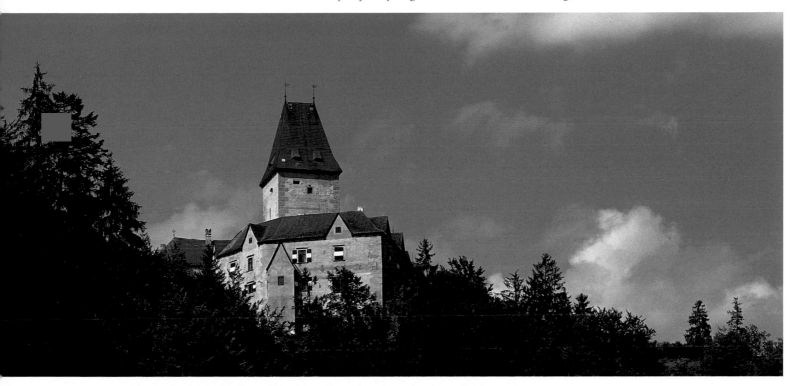

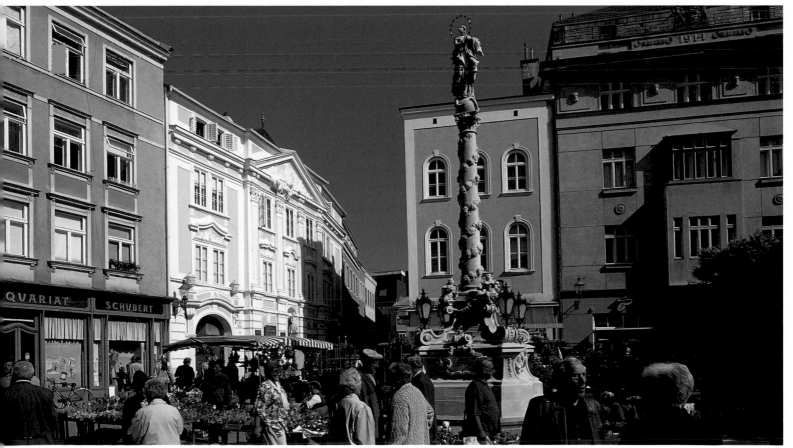

113

Below:
Seewinkel on the eastern shores of Lake Neusiedler is part of the Austro-Hungarian National Park. Herds of cows graze among the salt pools, where herons, storks and lapwings nest.

Right:
Along the over 3,000 miles (5,000 km) of cycle and farm tracks the occasional horse-drawn cart ferries tourists around.

Cattle farming has shaped the landscape around Lake Neusiedler. Piles of bundled reeds used to line stalls in the cold winter months are not an uncommon sight (centre left). Hiking trails which explore the nature reserve around Lange Lake start out from Apetlon with its pretty, gabled houses (left).

Above centre:
A quiet calm settles over nature's paradise on Lake Neusiedler in the evening. Its expanse of water and belt of reeds smack of the Hungarian steppe.

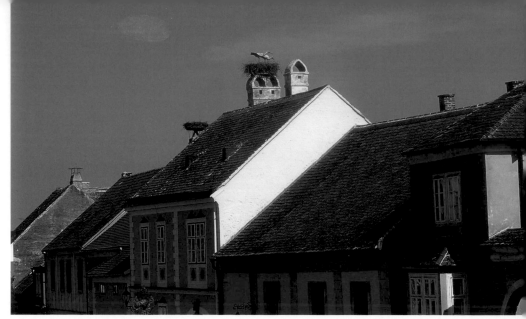

Below:
The fruits of the Burgenland gleam in the sun at the vegetable market in Eisenstadt, the provincial capital. The old town came to be known as the Freistadt or free city after the citizens bought their independence from the royal house of Esterházy in 1648.

Right:
A stork's nest on the roof is a symbol of pride for the people of Rust. In spring, home-owners repair the comfortable grilles on their chimneys and sprinkle them with lime paint to entice airborne visitors.

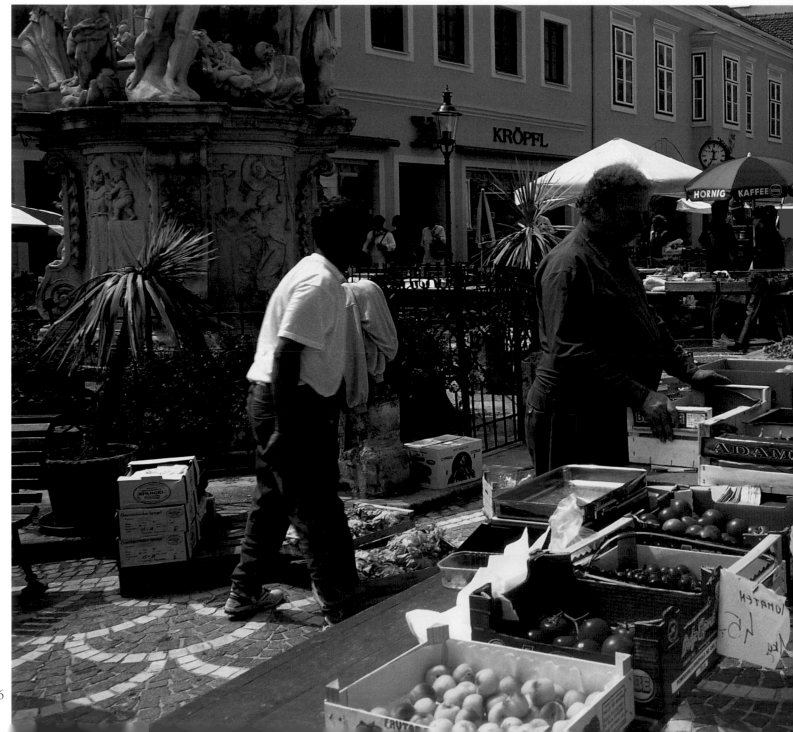

Piles of red peppers
harvested in the
Burgenland indicate
that Hungary is not far
away (left). Autumn is
also when corn cobs
are strung up outside
the farmhouses to dry
(below).

Above:
*Rust on Lake Neusiedler is not only a town of storks but also of Burgenland wine.
Selling the occasional box to passers-by is a welcome source of income for local
wine-growers.*

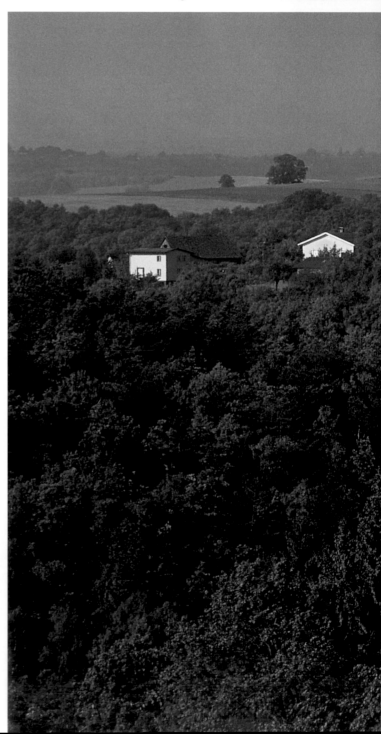

Below:
The House of Esterházy, to whom about a third of the northern Burgenland still belongs, resided at the castle in Eisenstadt for almost 300 years, from 1622 to 1944.

Below centre:
The knight's hall at Schloss Lockenhaus is a reminder of the early battles fought over land in the border country.

Bottom:
Ancient Forchtenstein Castle fell to the counts of Esterházy in 1622 after a long and turbulent history.

Main photo:
With walls over 16 ft (5 m) thick, Schlaining Castle was one of the most indomitable fortresses in the Burgenland.

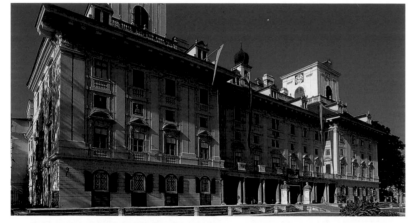

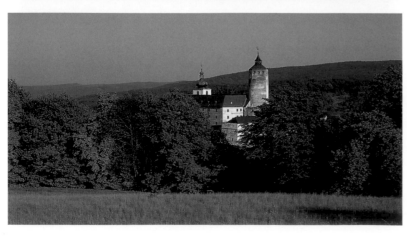

Left:
The old imperial hunting lodge in Halbthurn was given its baroque polish by architect Lukas von Hildebrandt in 1710.

Page 120/121:
One of the most charming wine villages in the Burgenland is Mörbisch on the Hungarian border to Lake Neusiedler. One of its typical features is the long farm alleys with their listed gables and barns.

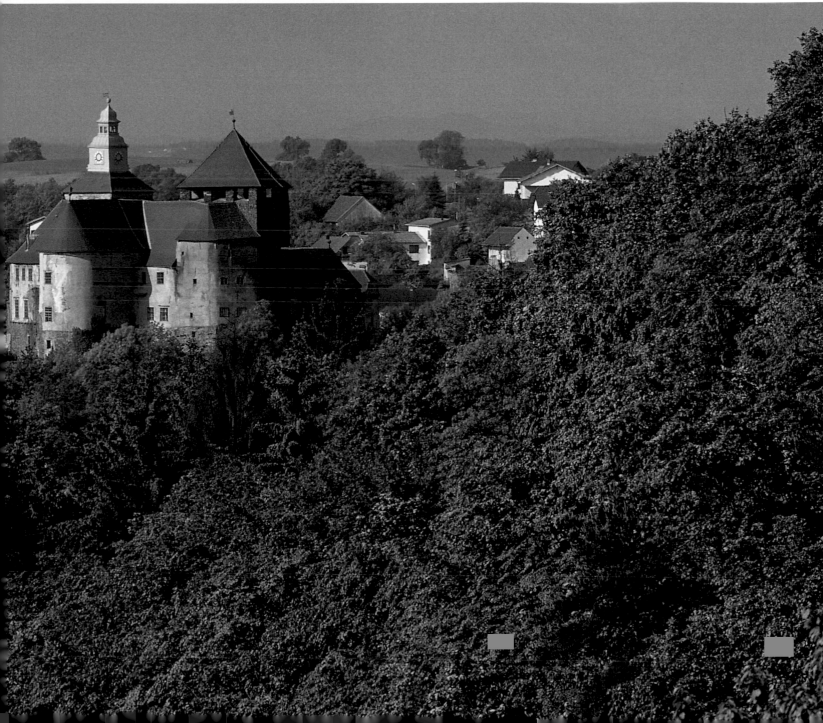

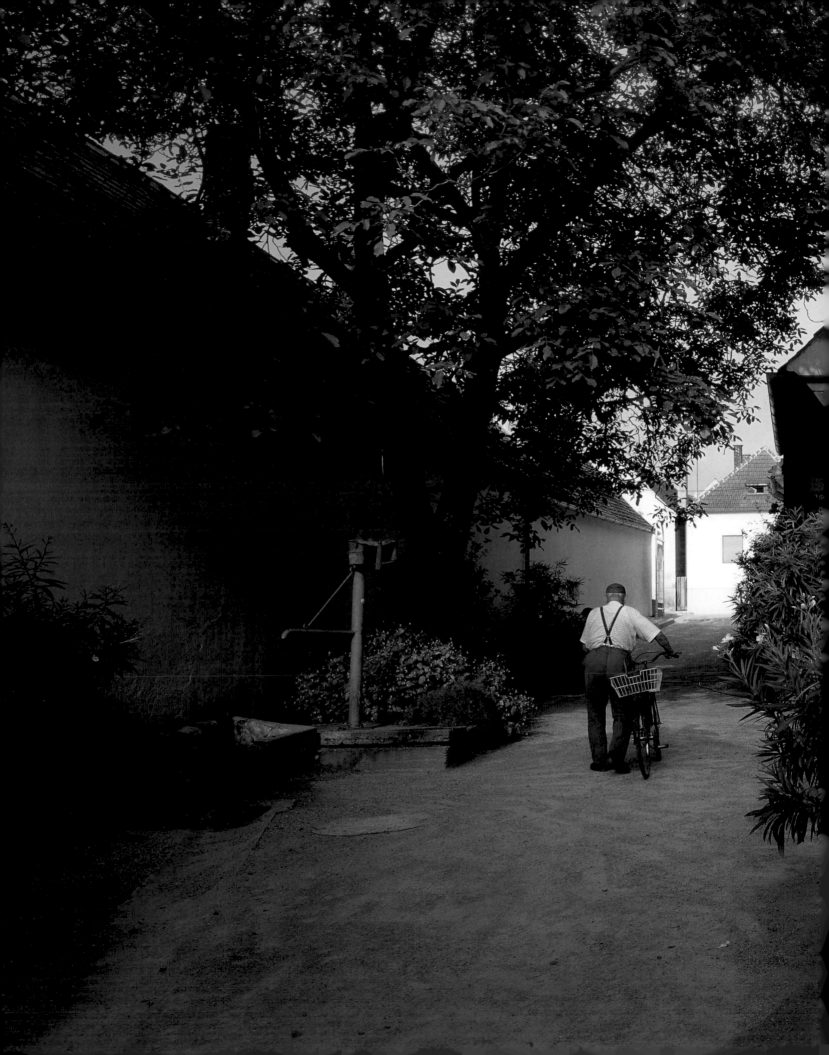

I N D E X

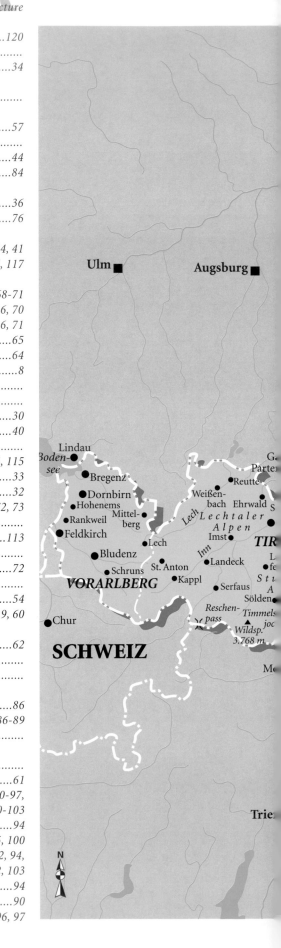

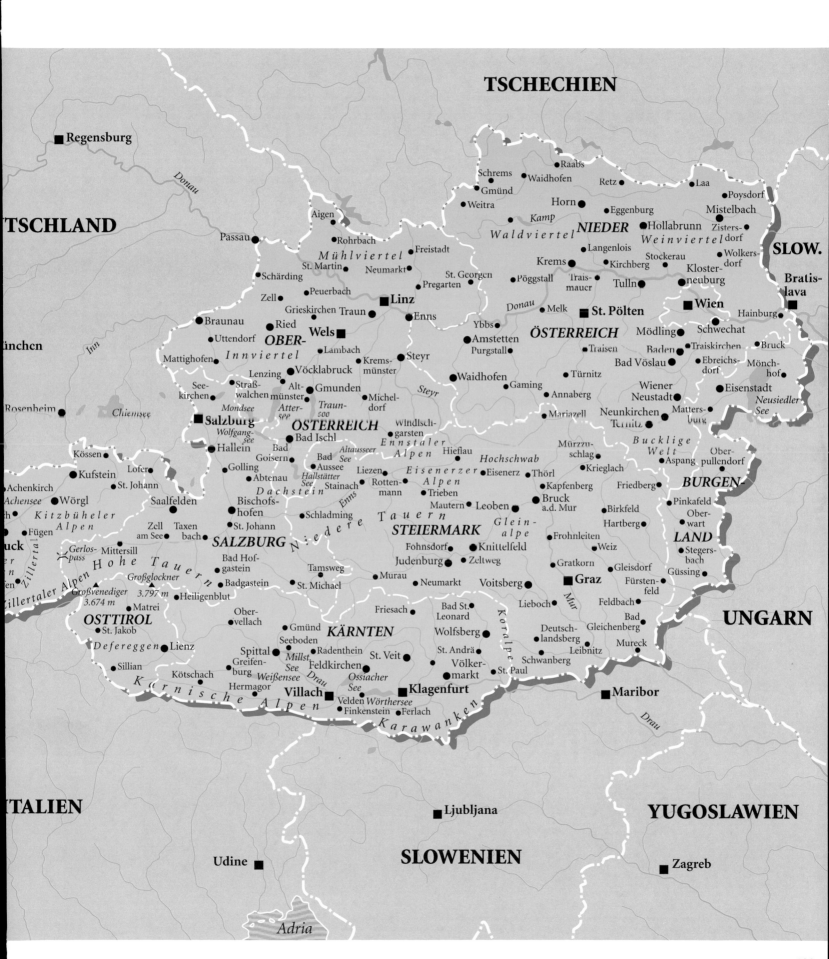

TSCHECHIEN

■ Regensburg

Donau

TSCHLAND

SLOW.

Passau ■

●Raabs
Schrems ● ●Waidhofen ● Retz ● ● Laa
● Gmünd ● Poysdorf
● Weitra Horn ● Eggenburg Mistelbach
Kamp **NIEDER** Zisters-
W a l d v i e r t e l ● Hollabrunn dorf
W e i n v i e r t e l
Aigen ● ● Langenlois Wolkers-
● Rohrbach Freistadt Krems ● Kirchberg Stockerau dorf
M ü h l v i e r t e l St. Georgen Pöggstall Trais- Kloster- Bratis-
St. Martin ● Neumarkt ● ● Pregarten maucr Tulln ● neuburg lava
Schärding ● ● *Donau* ● Melk St. Pölten ● ■ Wien
Zell ● Peuerbach ■ **Linz** Ybbs ● ■ **ÖSTERREICH** Hainburg ●
Braunau ● Grieskirchen Traun ● Enns Amstetten Mödling ● Schwechat
● Ried **OBER-** ● **Wels** ■ Purgstall ● Traisen Baden ● Traiskirchen Bruck ●
Uttendorf ● Lambach Steyr Bad Vöslau Ebreichs- Mönch-
Mattighofen ● *I n n v i e r t e l* Krems- Waidhofen ● ● Türnitz dorf hof ●
Lenzing ● Vöcklabruck münster Gaming ● Wiener Eisenstadt ●
See- Straß- Alt- *Steyr* ● Annaberg Neustadt *Neusiedler*
Rosenheim ● kirchen walchen münster Gmunden Michel- Mariazell ● Neunkirchen Matters- *See*
Chiemsee Mondsee *Atter- Traun- dorf* windisch- Türnitz burg
■ **Salzburg** *see see* ● **ÖSTERREICH** garsten *Mürzzu- Bucklige*
Wolfgang- Bad Ischl *Ennstaler* schlag *Welt* Ober-
Kössen ● Hallein ● *see* Bad ● *Alpen* Hieflau *Hochschwab* ● Krieglach ● Aspang pullendorf
Lofer ● Goisern *Altausseer* ● Eisenerz Thörl Friedberg **BURGEN-**
Kufstein ● ● St. Johann Golling ● Bad *See* Liezen ● Eisenerzer Kapfenberg ● Birkfeld ●
Achenkirch Abtenau ● Aussee Rotten- *Alpen* Leoben Bruck Hartberg ● Ober-
Achensee ● Wörgl Saalfelden ● *Dachstein Hallstätter* Stainach mann ● Trieben Mautern ● a.d. Mur wart ●
Kitzbüheler Bischofs- *See* Schladming ● *T a u e r n* ● *Glein-* **LAND**
Fügen ● *Alpen* hofen ● ● St. Johann *N i e d e r e* **STEIERMARK** *alpe* Frohnleiten ● Pinkafeld ●
ruck Zell Taxen- Fohnsdorf ● Knittelfeld ● Weiz ● Stegers-
Gerlos- Mittersill am See bach **SALZBURG** Judenburg ● ● Zeltweg Gratkorn ● Gleisdorf ● bach ●
pass *H o h e T a u e r n* Bad Hof- Tamsweg Murau ● Neumarkt Voitsberg ● ■ **Graz** Fürsten- Güssing ●
Zillertal gastein ● Lieboch ● feld
Zillertaler Alpen *Großglockner* Badgastein ● St. Michael ● Bad ● Feldbach
▲ ● Bad St. Deutsch- Gleichenberg
Großvenediger 3.797 m ● Heiligenblut Ober- Friesach ● Leonard landsberg ● Mureck ●
3.674 m ● Matrei vellach Wolfsberg ● Leibnitz ●
OSTTIROL Gmünd ● **KÄRNTEN** St. Veit ● St. Andrä ● Schwanberg ●
● St. Jakob Seeboden ● ● Völker- St. Paul ●
Defereggen ● Lienz Spittal ● Radenthein St. Veit markt
Greifen- *Millst. See* ● Feldkirchen ● *Ossiacher*
Sillian ● burg *Weißensee See*
Kötschach ● *Drau* Klagenfurt ■ ■ **Maribor**
Hermagor ● **Villach** ■ Velden *Wörthersee*
K a r n i s c h e A l p e ● Finkenstein ● Ferlach **UNGARN**
K a r a w a n k e n

ITALIEN Ljubljana ■ *Drau*

YUGOSLAWIEN

Udine ■ **SLOWENIEN** ● Zagreb

Adria

123

The Großglockner-Hochalpenstraße was built between 1930 and 1935. It winds up 27 bends and almost 30 miles (48 km) to a heady 8,219 ft (2,505 m).

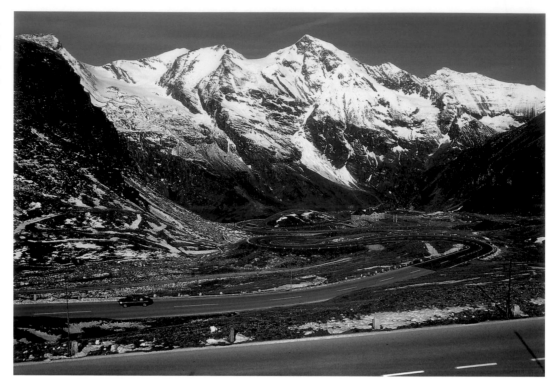

Credits

Photos:
All photos are by Martin Siepmann with the following exceptions: P. 34/35 (4 pictures), P. 98/99 (background), Archiv für Kunst und Geschichte, Berlin.

Design:
hoyerdesign grafik gmbh, Freiburg

Map:
Fischer Kartografie, Fürstenfeldbruck

Translation:
Ruth Chitty, Schweppenhausen

Printed in Germany
Reproductions by Artilitho, Trento
Printed and bound by:
Offizin Andersen Nexö, Leipzig
©2005 Verlagshaus Würzburg GmbH & Co. KG
©Photos: Martin Siepmann, Geretsried

ISBN 3-8003-0976-9

Stürtz